big color

color

Maximize the potential of your design through use of color

general editor: roger walton

BIG COLOR

First published in 2001 by:
HBI, an imprint of HarperCollins Publishers
10 East 53rd Street
New York, NY 10022-5299
United States of America

Distributed in the United States
and Canada by:
North Light Books, an imprint of
F & W Publications, Inc.
1507 Dana Avenue
Cincinnati, OH 45207
1-800-289-0963

Distributed throughout the rest
of the world by:
HarperCollins International
10 East 53rd Street
New York, NY 10022-5299
Fax: (212) 207-7654

ISBN: 0-688-16939-2

First published in Germany by Nippan
Nippon Shuppan Hanbai Deutschland GmbH
Krefelder Str. 85
D-40549 Düsseldorf
Tel: (0211) 504 80 80/89
Fax: (0211) 504 93 26
E-Mail: nippan@t-online.de

ISBN: 3-931884-84-8

Conceived, created, and designed by:
Duncan Baird Publishers
6th Floor, Castle House
75–76 Wells Street, London W1T 3QH

Designers: Paul Reid and Lloyd Tilbury at Cobalt id
Editor: Marek Walisiewicz at Cobalt id
Project Co-ordinator: Tara Solesbury

10 9 8 7 6 5 4 3 2 1

Typeset in Meta Plus
Color reproduction by Scanhouse, Malaysia
Printed in Singapore

NOTE
All measurements listed in this book
are for width followed by height.

CONTENTS

Color is an integral part of every design – even black text on a white page. Along with type and imagery it is a key building block in all visual communication. Skilful use of color can transform the mundane into the sublime: color can evoke an atmosphere, analyze and signpost information, draw and divert attention, attract or repel, provoke or soothe. Big Color presents a stunning portfolio of design work, gathered from around the world, which exemplifies the use of color in a range of applications – from corporate stationery to web design. Its aim is to inspire and inform – to show how color can help you communicate.

A growing range of techniques allows designers to exploit color to the full. Color images – photographs or artworks – can be reproduced with remarkable veracity on

FOREWORD

printing presses that use four or even six process inks; specially-mixed inks can, in theory, match any hue, even fluorescent or metallic; and color can be controlled by choice of paper stock and finishing technique, such as varnishes and laminates. Despite continuing technical advances in color reproduction the designer's most precious resource remains imagination – as the following pages clearly testify.

Like other aspects of graphic design, use of color changes with time. Frequently, it is driven by, and drives fashion in its broadest context. In this book, work is arranged not according to perceptions of style or technical specification but by palette. In this way, each piece of work stands on its own as an example of the designer's skill and imagination.

RW

Lo-Beam work in this section demonstrates the wide range of effects that can be achieved using subtle, muted color.

1

BD#01072

bulletproof design

" WE ARE PEOPLE WHO THINK OF DESIGN AS MORE OF A LIFESTYLE...
DESIGNERS SHOULD BE 24/7"

bulletproof portfolio
the front and back covers of this self-promotional portfolio use subtle blue
tones with red to highlight the company's name and personnel. The abstract
patterning is developed and carried through the interior pages (see over).

contact

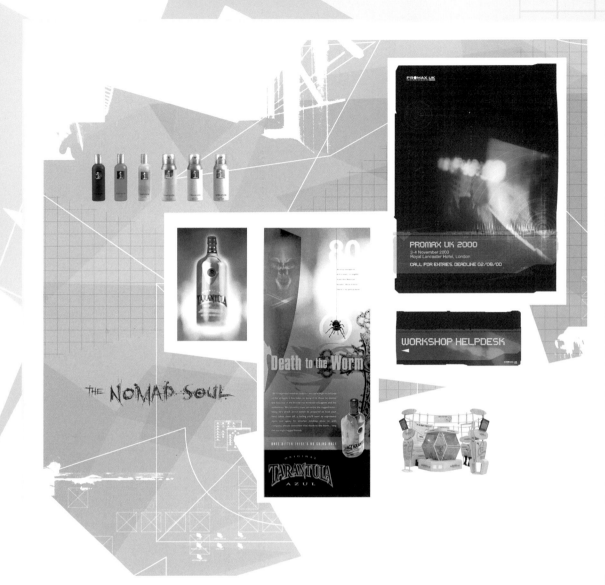

bulletproof portfolio

work undertaken for clients is grouped on each page according to color palette; a muted tint of the dominant color is used in the background to create an almost architectural grid-based design, which helps integrate disparate elements into a visually resolved whole. The portfolio is presented as individual sheets enclosed in a wrapper of tracing paper, giving a precious, tactile element to the work.

Designer
Matthew Kerr

Art Director
Gush Mundae

Design Company
Bulletproof Design

Country of Origin
UK

Description of Artwork
Cover of self-promotional brochure and portfolio pages

Dimensions
300 x 300 mm
12 x 12 in

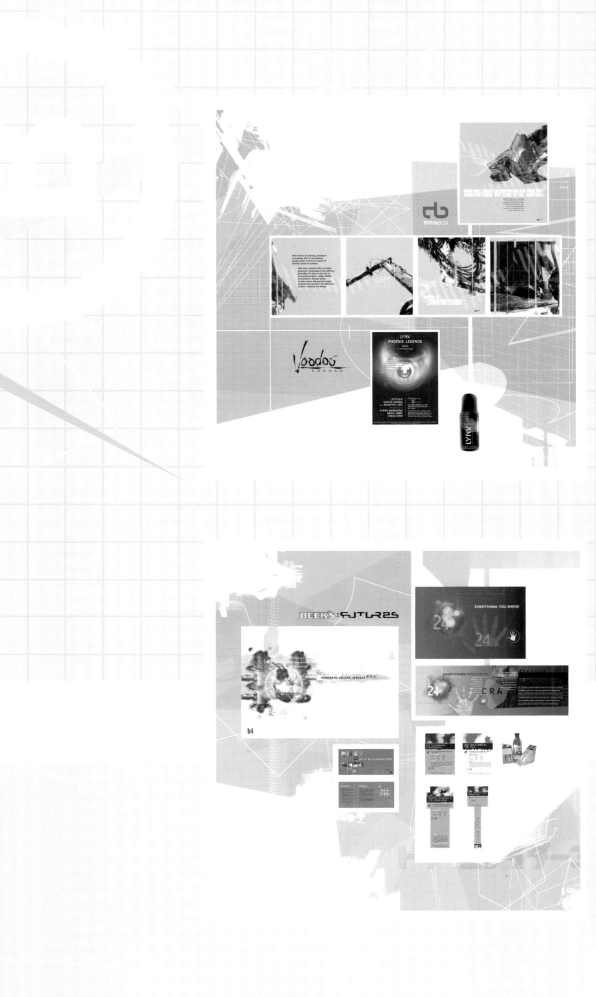

Cobalt Business Park is much more than commercial property. It is a package of benefits that will give your business a real advantage. The Cobalt advantage.

high specification

The Cobalt 3 specification will include:
- 1.5 metre module / 7.5 metre structural grid
- 175mm raised computer access floor throughout
- Clear 500mm ceiling void throughout
- 2.6 metre floor-to-ceiling height
- 6.4 metre height reception area
- Floor slabs designed to carry a 6.5 KN/m² loading
- Double glazed windows with antisun glass
- Ash veneers to all woodwork
- Well lit external areas with CCTV
- Capacity to install full air conditioning

ground floor plan

Building 1 (3 storey)
Total 3,709.59 sq.m. (40,142 sq.ft.) net
Ground floor 1,220.33 sq.m. (13,136 sq.ft.) net
1st floor 1,240.59 sq.m. (13,354 sq.ft.) net
2nd floor 1,208.27 sq.m. (13,652 sq.ft.) net

Building 2 (3 storey)
Total 2,791.63 sq.m. (30,050 sq.ft.) net
Ground floor 912.84 sq.m. (9,826 sq.ft.) net
1st floor 932.81 sq.m. (10,041 sq.ft.) net
2nd floor 946.08 sq.m. (10,183 sq.ft.) net

Building 3 (2 storey)
Total 1,854.36 sq.m. (19,961 sq.ft.) net
Ground floor 918.72 sq.m. (9,889 sq.ft.) net
1st floor 935.64 sq.m. (10,072 sq.ft.) net

Buildings 1 & 2 can be linked to provide
7,011 sq.m. (75,472 sq.ft.) net lettable space

open space

Cobalt 3 site plan

Cobalt Business Park

Space is a dominant theme at Cobalt Business Park. Space to work in close proximity to the city and communication nodes.

Cobalt 3 is located on the A19, 5 miles from Newcastle City Centre and 5 within a 20 minute drive of Newcastle International Airport.

At its heart is the 39 acres of Countryside Park.

With the bridgeways, the open space and the intensive landscaping, you will feel miles from anywhere. You are not. This is another Cobalt advantage.

You will feel part of the most dynamic business district in the North East — in a business city.

The Cobalt advantage offers the best of all worlds.

Designer
Gareth Howat

Art Director
Gareth Howat

Illustrator
Stephen Conlin

Design Company
Lapot Ltd

Country of Origin
UK

Description of Artwork
Cobalt Business Park brochure

Dimensions
210 x 297 mm
8¼ x 11¾ in

cobalt brochure

reducing color contrast between the elements is a way of establishing a strong color-based identity for this business park. The dominant color, cobalt, is a clear reference to the name of the company itself. The use of one overriding color allows the consistent presentation of imagery – abstracted aspirational images sit alongside information-rich diagrams without jarring.

type œ+

2RebeLS

thèque
foundry

2R-176 » 2R-200

info@2rebels.com

(514) 481.098

(800) 500.0984

4623 harvard
Montréal (Québec)
H4A 2X3 canada

Designers
Pol Baril, Denis Dulude, Fabrizio Gilardino

Art Directors
Denis Dulude, Fabrizio Gilardino

Design Company
2 Rebels

Country of Origin
Canada

Description of Artwork
Fontbook catalog

Dimensions
140 x 297 mm
5 1/2 x 11 3/4 in

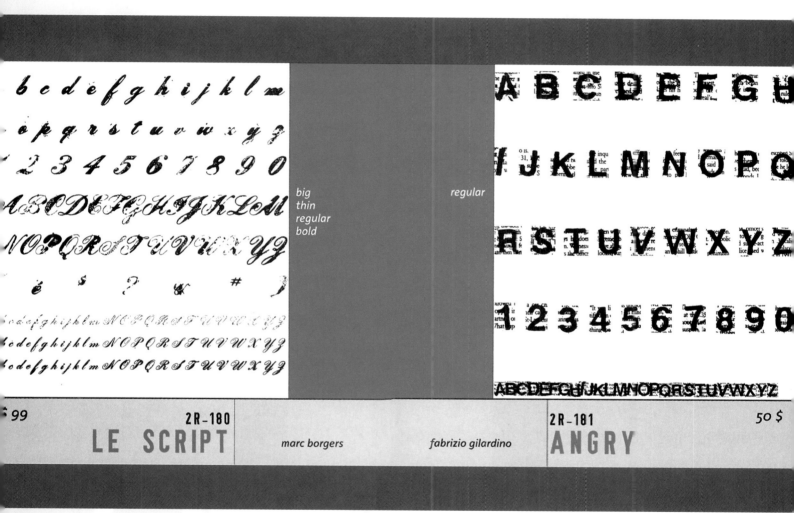

2 rebels typefoundry catalogue

promoting typefaces is difficult. Growing competition means that type foundries can no longer rely on simply presenting their products unadorned. Here, 2 rebels advertises its products by showcasing a gothic script on an eerie scene, reminiscent of a horror movie. The olive-green duotones accentuate the atmosphere and give the designers flexibility to reverse type out from the images or overprint in black, maintaining mood with the economy of two-color print. Clever use of a single image printed as a positive and a negative squeezes maximum value from one shot.

prototype font kit

automatic art and design handles font advertising in a very different way to 2 rebels (see page 16). Its approach is more whimsical, using a surreal montage to suggest the creative possibilities of using its fonts. Old-fashioned mechanical type production is suggested by a "conceptual machine," which calls to mind values of traditional craftsmanship, albeit applied in an innovative manner. Use of fashionable retro block color chimes in with the found 1950s-style imagery.

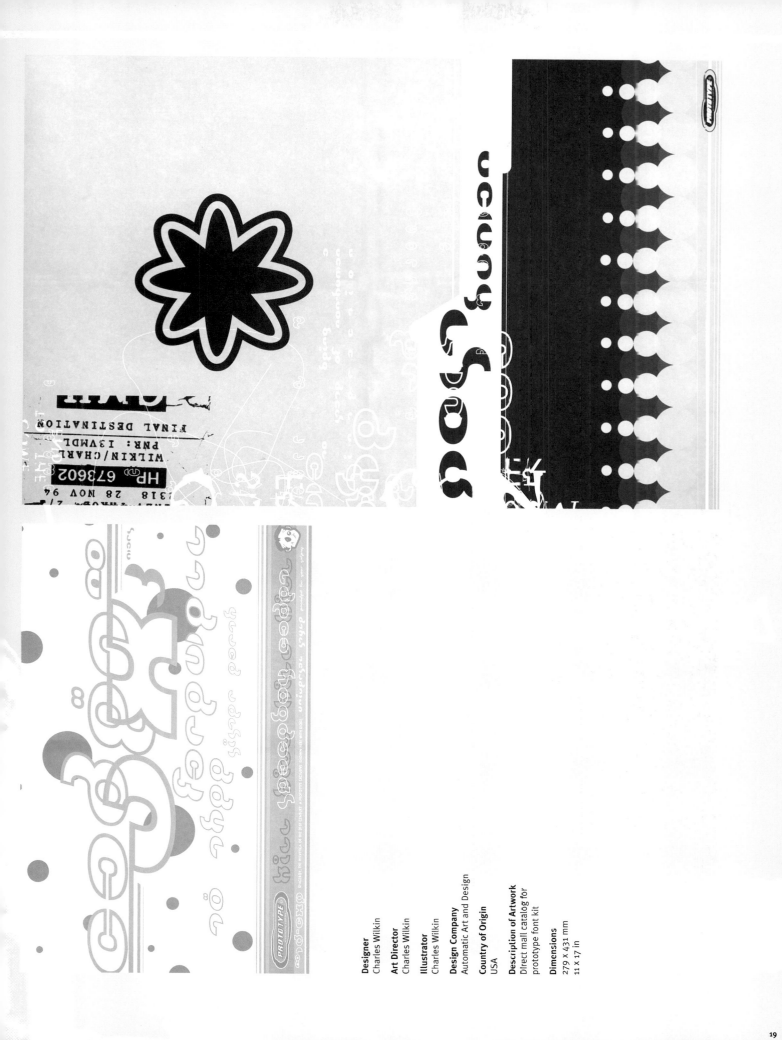

Designer
Charles Wilkin

Art Director
Charles Wilkin

Illustrator
Charles Wilkin

Design Company
Automatic Art and Design

Country of Origin
USA

Description of Artwork
Direct mall catalog for
prototype font kit

Dimensions
279 x 431 mm
11 x 17 in

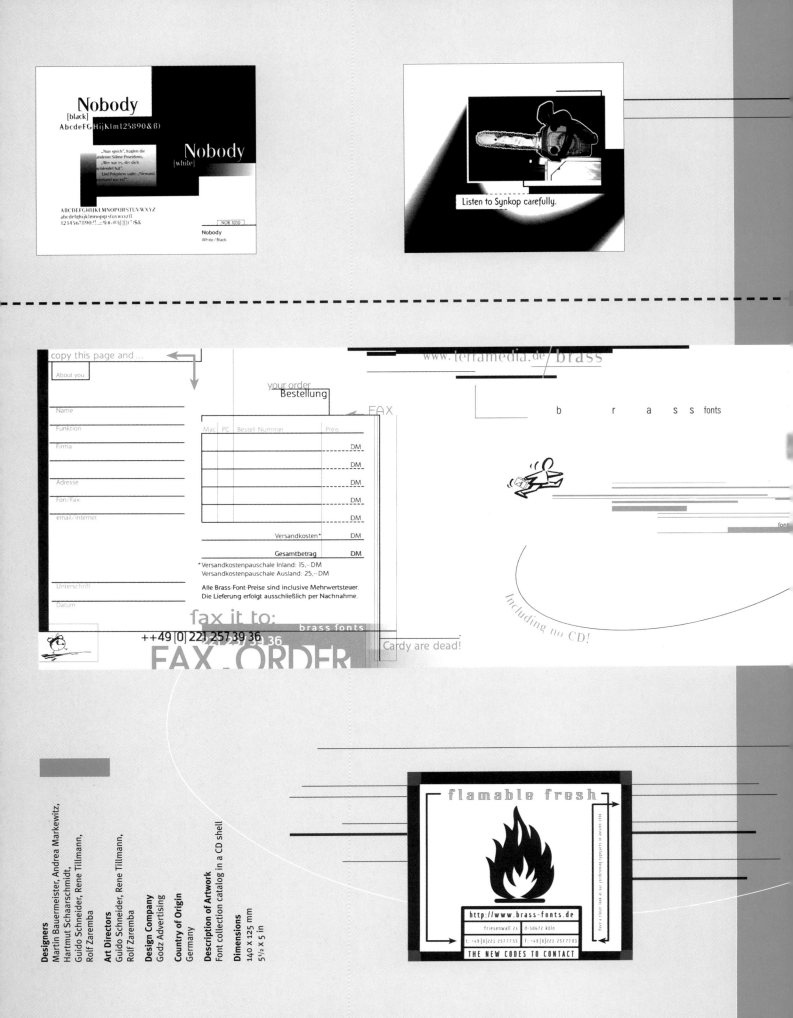

Nobody
[black]
AbcdeFGHijKlm125890&ß)

"Nun sprich", fragten die
andreen Söhne Poseidons,
„Wer war es, der dich
geblendet hat?",
Und Polyphem sagte: „Niemand,
niemand war es!".

Nobody
[white]

ABCDEFGHIJKLMNOPQRSTUVWXYZ
abcdefghijklmnopqrstuvwxyzß
1234567890?!.,:;%#-@§|[]()"'}$&

NOB 3010

Nobody
White/Black

Listen to Synkop carefully.

copy this page and ...

About you:

your order
Bestellung

FAX

www.terramedia.de/brass

b r a s s fonts

Name

Funktion

Firma

Mac	PC	Bestell Nummer	Preis	
				DM
				DM
				DM
				DM
				DM
		Versandkosten*		DM
		Gesamtbetrag		DM

Adresse

Fon/Fax

email/internet

*Versandkostenpauschale Inland: 15,–DM
Versandkostenpauschale Ausland: 25,–DM

Alle Brass-Font-Preise sind inclusive Mehrwertsteuer.
Die Lieferung erfolgt ausschließlich per Nachnahme.

Unterschrift

Datum

fax it to:

brass fonts

++49 [0] 221 257 39 36

Cardy are dead!

FAX_ORDER

Including no CD!

Designers
Martin Bauermeister, Andrea Markewitz,
Hartmut Schaarschmidt,
Guido Schneider, Rene Tillmann,
Rolf Zaremba

Art Directors
Guido Schneider, Rene Tillmann,
Rolf Zaremba

Design Company
Godz Advertising

Country of Origin
Germany

Description of Artwork
Font collection catalog in a CD shell

Dimensions
140 x 125 mm
5½ x 5 in

flamable fresh

http://www.brass-fonts.de

friesenwall 24 d-50672 köln

t: +49 [0]221 2577755 f: +49[0]221 2577703

THE NEW CODES TO CONTACT

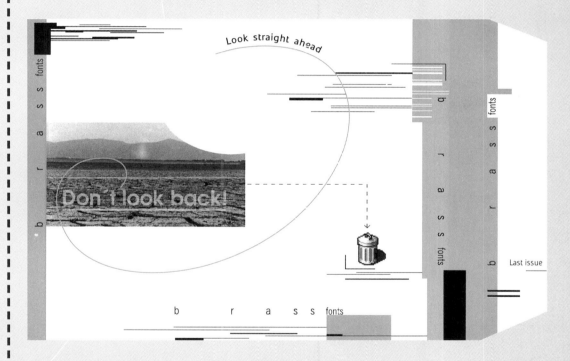

b r a s s

analogue catalogue

Look straight ahead

Don't look back!

b r a s s fonts

Last issue

brass fonts
like 2 rebels and automatic art and design, brass fonts uses the color green in the promotion of its fonts. Here the green is employed as a typographic counterpoint – a visual exclamation point – and also helps to order the information on a form to be completed by the client. The formal asymmetric arrangement of monochrome imagery and type evokes the Swiss style of typography from the 1960s. Such an objective, analytical approach is well suited to the promotion of type.

D·U·B·U·C
MODE DE VIE

autom-
ne

fall
9 8

dubuc brochure

the bold decision to place dark suits on a monochrome
background succeeds here because the clothing is
thrown into relief by shunning the distraction of color.
The industrial setting and high-contrast imagery
accentuate the sharp lines of the clothing, while
textures in the grainy backgrounds echo the surface
textures of the fabrics.

above: cover
right: inner spreads

Designers
Pol Baril, Denis Dulude

Art Director
Pol Baril

Photographer
Serge Barbeau

Design Company
KO Creation

Country of Origin
Canada

Description of Artwork
Product catalog

Dimensions
195 x 245 mm
7³/₄ x 9³/₄ in

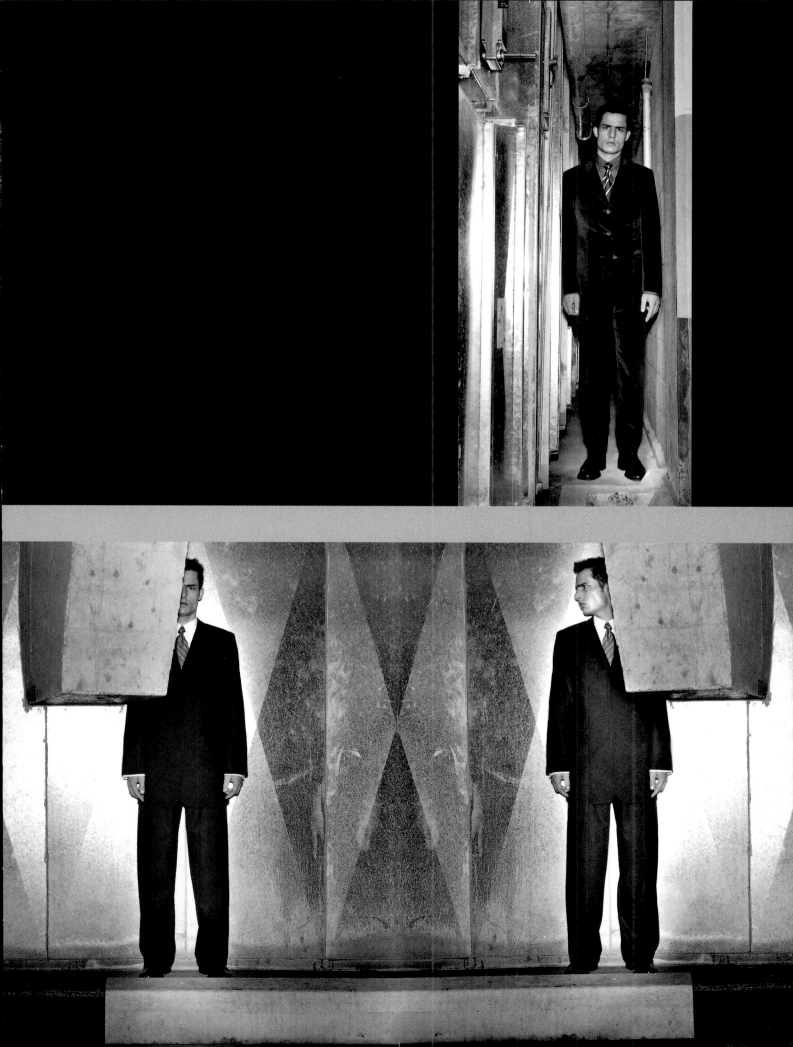

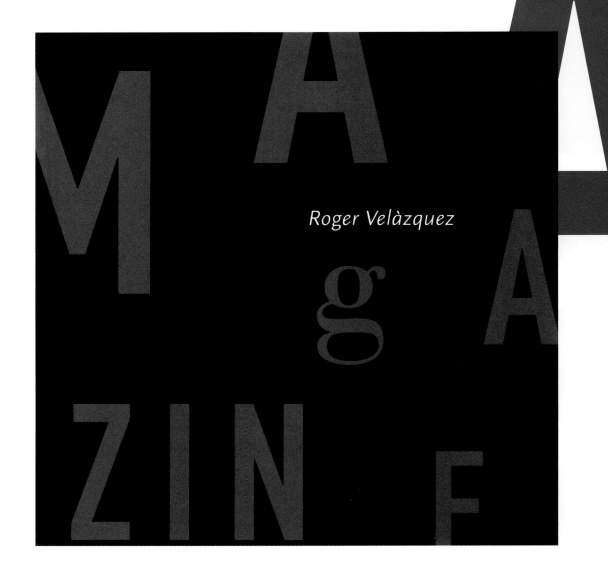

Roger Velàzquez

magazine, roger velázquez
although the colors here are strong, the contrast between
them is low, resulting in a reassuringly rich texture for this
exhibition catalog. Elements on each spread are grouped
harmoniously according to their tone, and each
composition is further united by related color elements,
such as the rose, the letter "G" and the image background
(top right). In the final spread (bottom right), careful
image editing sets up a visual game through the playful
repetition of red elements.

Designers
Lluis Jubert,
Ramon Enrich

Art Director
Ramon Enrich

Photographer
Roger Velazquez

Design Company
Espai Grafic

Country of Origin
Spain

Description of Artwork
Catalog for a
photographic exhibition

Dimensions
150 x 150 mm
4^{7}/$_{8}$ x 4^{7}/$_{8}$ in

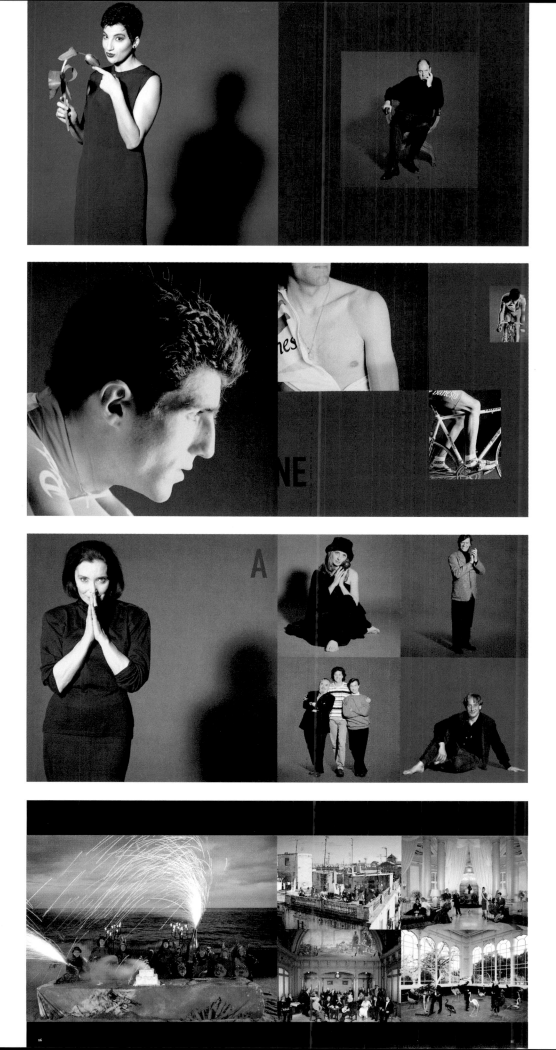

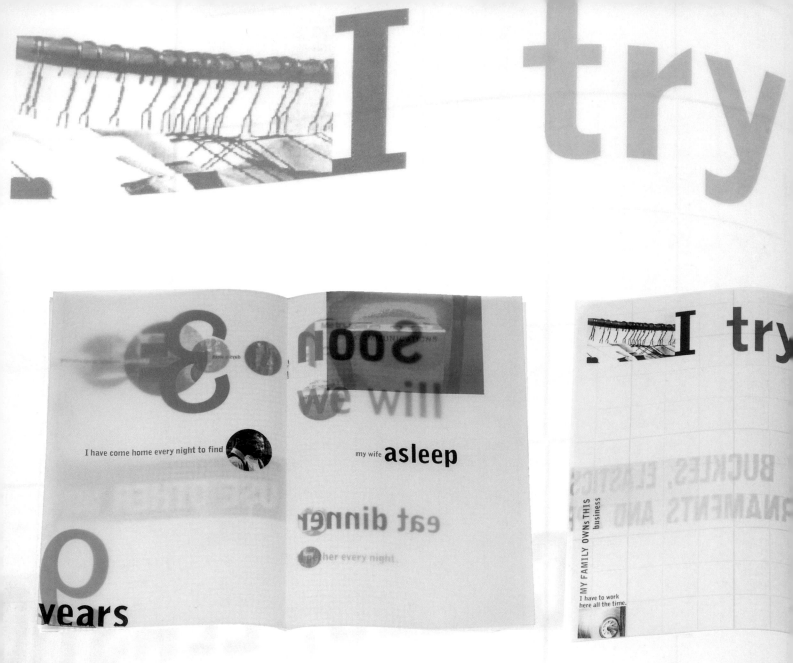

lost in thoughts: interviews while working
this is a visual representation of random thoughts that people have while at work, and its layered appearance suggests the many levels of consciousness that one can occupy while awake. Printing on tracing paper allows a play on tones of the same color and adds a dreamlike quality to the way in which the reader perceives the information. The tracing paper also produces a blue, watery impression – a stream of consciousness in which words flow off the page and even reverse direction, allowing glimpses of meaning.

Designer
Stella Bugbee

Art Director
Stella Bugbee

Photographer
Video Stills by Stella Bugbee

Design Company
Agenda

Country of Origin
USA

Description of Artwork
A three-part series of books based on interviews with people who hold menial jobs

Dimensions
133 x 203 mm
5¼ x 8 in

not to

hink about college

Sometimes, My body is here, but my mind is in *SANTIAGO.*

I pray sometimes

I try

supernatural presents

Ego EvolutioN 1

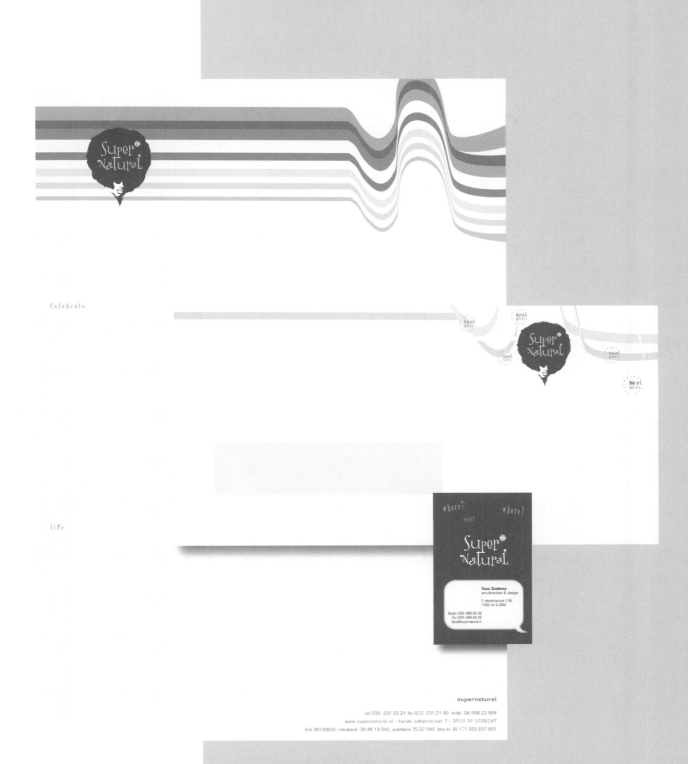

Designer
Taco Zuidema

Art Director
Taco Zuidema

Design Company
Taco Visual Communications

Country of Origin
The Netherlands

Description of Artwork
Stationery range and
promotional postcard

Dimensions
Various

supernatural poster/stationery

this designer's stationery and self-promotional flyer use retro imagery, typography, and color to evoke the style of the 1970s. Although the letterhead appears to comprise nine special colors, it is ingeniously printed in just three – dark brown, yellow, and white. Unusually, it is printed on cream stock, with a single white band screen-printed on top; wittily, the words "celebrate" and "life" indicate fold lines. The flyer (left) uses the same technique to build a bold color spectrum: the brown and blue shades are earthy and calm, yet are used to startling effect in a retro psychedelic composition.

alliance of artists' communities stationery

this stationery range uses a palette similar to that employed by Taco Zuidema (see page 29), to very different effect. The image of a mature tree, combined with earthy colors, suggests an organization with established roots, and the use of type enclosed in linked circles suggests strength through co-operation. One- and two-color printing produces variety in the stationery range without compromising the clear identity.

Designer
Rob Bonds

Photographer
Rob Bonds

Design Company
Visual Resource Society

Country of Origin
USA

Description of Artwork
Stationery and note pad for a non-profit arts organization

Dimensions
Various

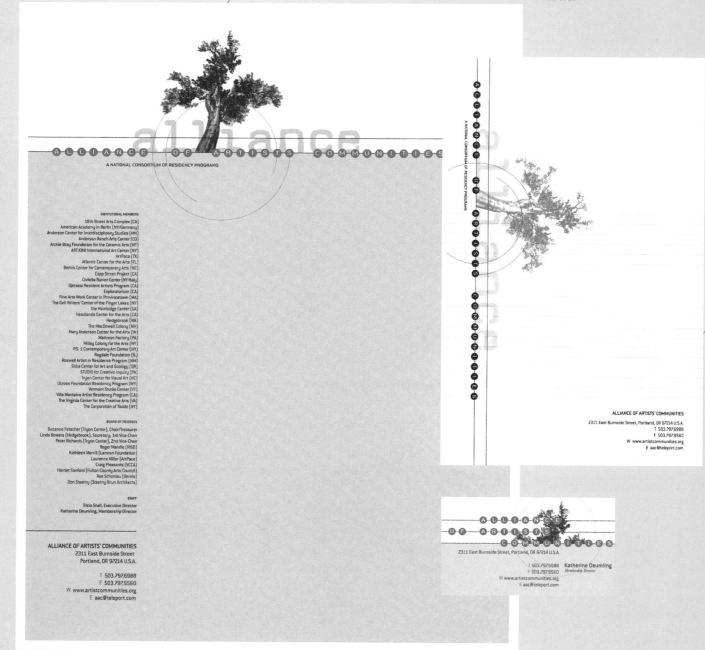

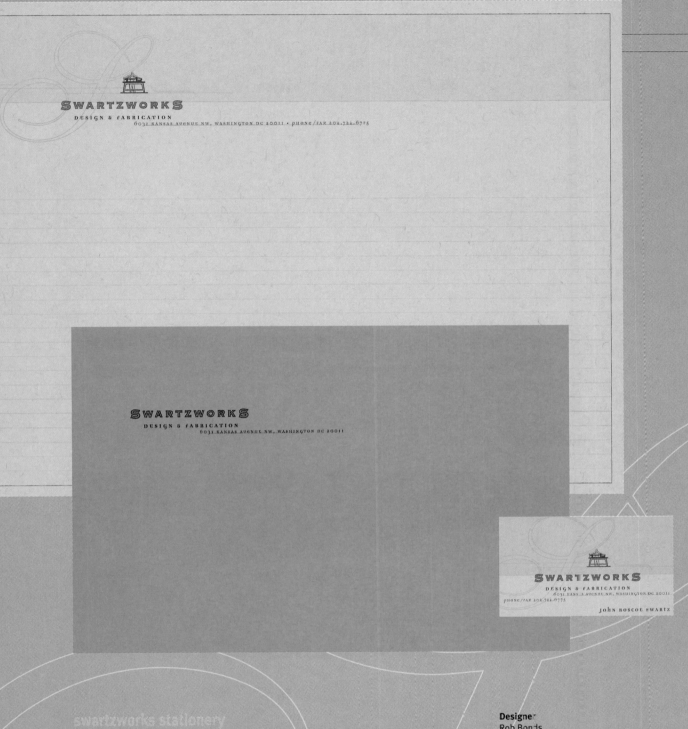

shades of earthy colors are used on tinted stock, creating
a subtle and harmonious range of stationery. The scripted
"S" in the background is reminiscent of an engraving or
watermark, adding an air of distinction to the stationery.

Designer
Rob Bonds

Design Company
Visual Resource Society

Country of Origin
USA

Description of Artwork
Stationery for a small
furniture studio

Dimensions
Various

ejm 1-2

this invitation from French dance company ejm uses lines of color tint to create a graceful impression of movement, which is reinforced by a typeset timescale along the horizontal axis. Darker blueish shades in the background are overlaid with brighter green panels that hold information about the event: these appear to float above the background, suspended in space and time. The contrast between the two "speeds" conveyed by the two colors reflects the titles of the two pieces performed – "Man Walking at Ordinary Speed," and "Inertia".

Designers
Nathalie Pollet, Kate Houben

Art Directors
Nathalie Pollet, Kate Houben

Illustrators
Nathalie Pollet, Kate Houben

Photographer
Pino Pipitone

Design Company
Designlab

Country of Origin
Belgium

Description of Artwork
Invitation to a dance performance

Dimensions
400 x 220 mm
15 3/4 x 8 2/3 in

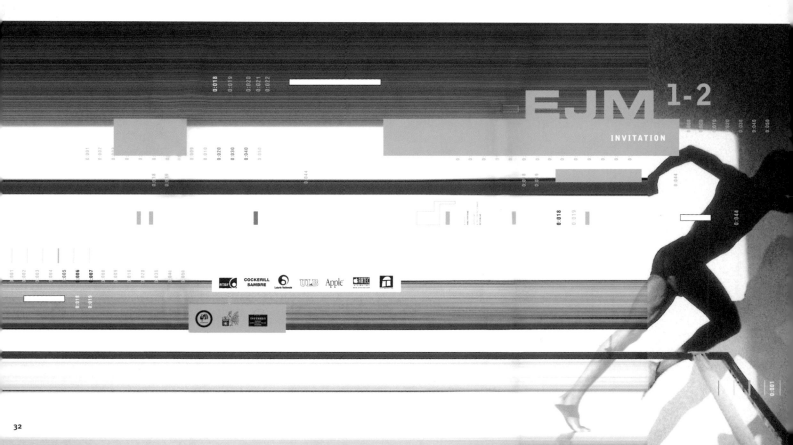

EJM¹⁻²

FRÉDÉRIC FLAMAND / DILLER+SCOFIDIO

CHARLEROI/DANSES . PLAN K
EJM¹ . MAN WALKING AT ORDINARY SPEED
BALLET DE L'OPÉRA NATIONAL DE LYON
EJM² . INERTIA

CHARLEROI/DANSES,
CENTRE CHORÉGRAPHIQUE DE LA COMMUNAUTÉ FRANÇAISE DE BELGIQUE
ET **PLAN K**
ONT LE PLAISIR DE VOUS INVITER À LA PREMIÈRE BELGE* DE

EJM¹ - MAN WALKING AT ORDINARY SPEED
CHORÉGRAPHIE DE FRÉDÉRIC FLAMAND POUR LA COMPAGNIE CHARLEROI/DANSES . PLAN K

EJM² - INERTIA
CHORÉGRAPHIE DE FRÉDÉRIC FLAMAND POUR LE BALLET DE L'OPÉRA NATIONAL DE LYON

23 . 24 . 25 & 26 SEPTEMBRE 1998 . 20H30
AUX **HALLES DE SCHAERBEEK**
22a RUE ROYALE 5ᵐᵉ MARIE . 1030 BRUXELLES

INVITATION STRICTEMENT PERSONNELLE VALABLE POUR 2 PERSONNES
VEUILLEZ NOUS RENVOYER LE COUPON RÉPONSE CI-JOINT DÛMENT COMPLÉTÉ
LES PLACES SONT À RETIRER AU SERVICE PROTOCOLE LE SOIR DE LA REPRÉSENTATION

NOM
PRÉNOM
ORGANISM
FONCTION
ADRESSE

TÉLÉPHONE

SOUHAITE RÉSERVER :

1 OU **2** PLACES

POUR LE :

23
24
25
26

À RENVOYER À CHARLEROI/DANSES - SERVICE PRESSE, AVANT LE 14 SEPTEMBRE
PAR COURRIER CHARLEROI/DANSES, 45 RUE DU FOËT - 6000 CHARLEROI
PAR FAX : + 3l 00171 20 56 49

CO-PRÉSENTATEUR: LA MONNAIE DE MUNT

AVEC L'AIDE DU COMMISSARIAT GÉNÉRAL AUX RELATIONS
INTERNATIONALES DE LA COMMUNAUTÉ FRANÇAISE DE BELGIQUE

CGRI

JANET CARDIFF &
GEORGE BURES MILLER

ÂNGELA FERREIRA

YEREBATAN SARNICI
THE YEREBATAN CISTERN

A. K. DOLVEN>WILLIAM KENTRIDGE>EVA MARISALDI> AYDAN MURTEZAOĞLU>TONY OURSLER>GÜNEŞ SAVAŞ>

**6th international
istanbul biennial book**

the purity of the jacket design is
in stark contrast to the colorful
juxtaposition of artworks within.
A conscious opposite to the
contents of the book, the cover
gives the event its own identity
rather than competing with the
works. The predominantly white
jacket is printed in one color to
produce the embossed effect,
and the use of gray – a "non-
color" – for this purpose maintains
the neutrality of the cover.

Designers
Gulizar Cepoglu, Aysun Pelvan

Art Director
Gulizar Cepoglu

Photographer
Manuel Citak

Design Company
Gulizar Cepoglu Design Co.

Country of Origin
Turkey

Description of Artwork
The second book of the Istanbul Biennial

Dimensions
165 x 230 mm
6¹/₂ x 9 in

S|3

SECTEUR

secteur trois

broadcast design

145, rue st-pierre #201 montréal québec H2Y 2L6 t) 514 287 9924 f) 514 287 7441

SECTEUR

broadcast design

145, rue st-pierre #201 montréal québec H2Y 2L6

S|3

broadcast design

secteur trois

145, rue st-pierre #201 montréal québec H2Y 2L6 t) 514 287 9924 f) 514 287 7441

info@secteur3.com

secteur 3

here distressed, dirty color and disintegrating type echo the quasi-military, underground name of this broadcast design company, placing it at the cutting edge of its medium. The motifs used on the two promotional postcards – an architectural blueprint and gritty voyeurism – are distinguished by the use of color, thus emphasising the treatment of color as an integral part of the company's visual identity.

Designers
KO Creation

Art Directors
KO Creation

Design Company
KO Creation

Country of Origin
Canada

Description of Artwork
Stationery and promotional postcards for a broadcast design company

Dimensions
Various

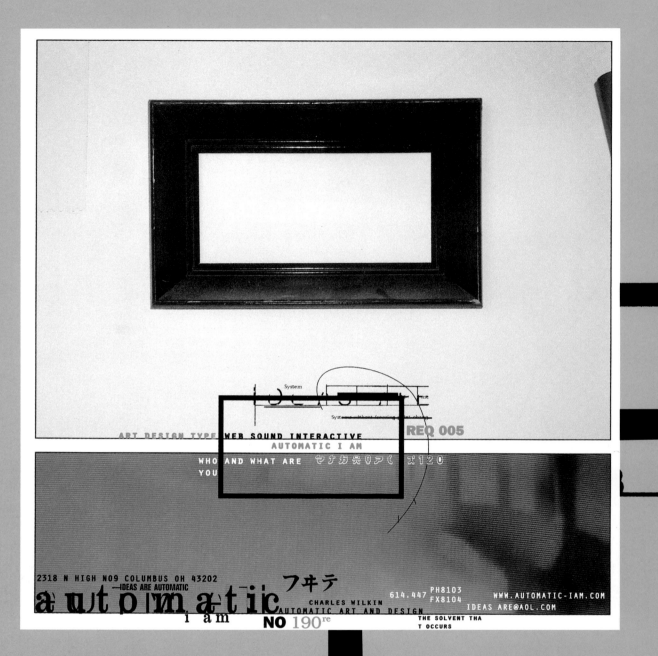

ART DESIGN TYPE WEB SOUND INTERACTIVE REQ 005
AUTOMATIC I AM

WHO AND WHAT ARE ヤナガ来のアイ ズ120
YOU

2318 N HIGH NO9 COLUMBUS OH 43202
—IDEAS ARE AUTOMATIC
automatic フヰテ
i am NO 190^re CHARLES WILKIN
AUTOMATIC ART AND DESIGN 614.447 PH8103 WWW.AUTOMATIC-IAM.COM
FX8104 IDEAS ARE@AOL.COM
THE SOLVENT THA
T OCCURS

automatic art and design

the name of this design group drives its
identity. The suggestion of a mechanical
process that occurs without human
intervention is achieved by the choice of
heavy black line and type and apparent
incorrect alignment of visual elements.
The use of a punched manila-colored card
(reminiscent of an industrial environment)
for the compliments slip reinforces this
idea. The strong approach to typography
allows the designers to use very different
imagery and colors to promote the studio.

Designer
Charles Wilkin

Art Director
Charles Wilkin

Illustrator
Charles Wilkin

Design Company
Automatic Art and Design

Country of Origin
USA

Description of Artwork
Creative book advertisement for
Automatic Art and Design

Dimensions
216 x 216 mm
8¹/₂ x 8¹/₂ in

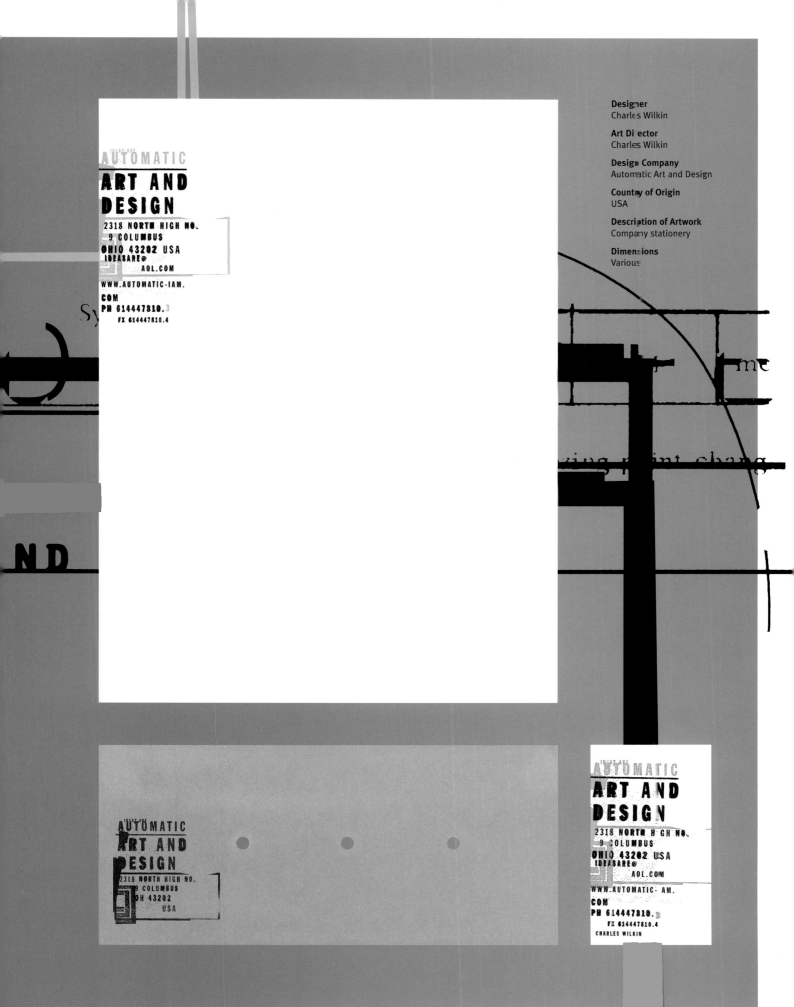

Designer
Charles Wilkin

Art Director
Charles Wilkin

Design Company
Automatic Art and Design

Country of Origin
USA

Description of Artwork
Company stationery

Dimensions
Various

AUTOMATIC
ART AND
DESIGN
2318 NORTH HIGH NO.
9 COLUMBUS
OHIO 43202 USA
IDEASARE@
AOL.COM
WWW.AUTOMATIC-IAM.
COM
PH 614447810.3
FX 614447810.4

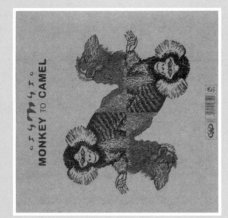

MONKEY TO CAMEL

Designers
Luke Davis, Paul Humprey

Art Directors
Luke Davis, Paul Humprey

Illustrators
Luke Davis, Paul Humprey

Design Company
Insect

Country of Origin
UK

Description of Artwork
Record sleeve

Dimensions
254 x 254 mm
10 x 10 in

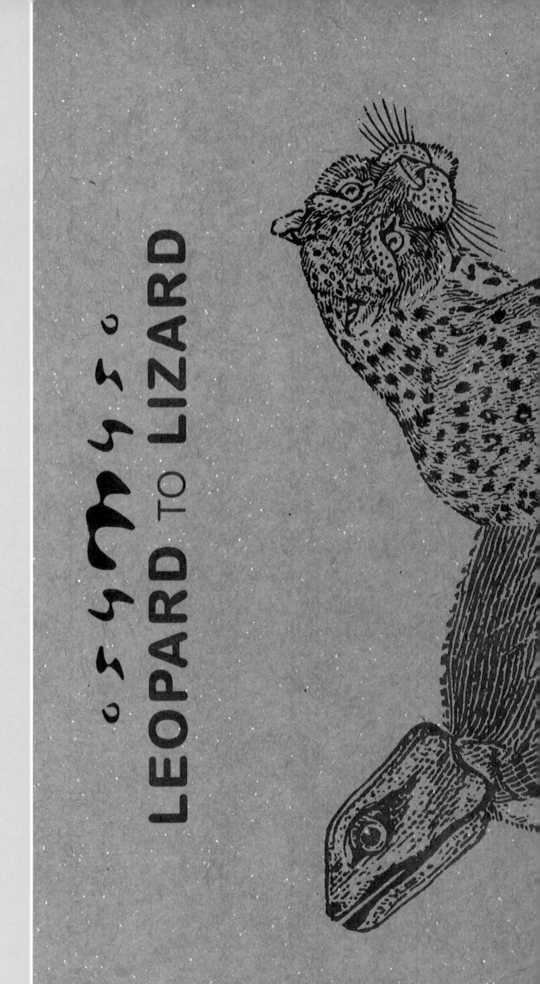

LEOPARD TO LIZARD

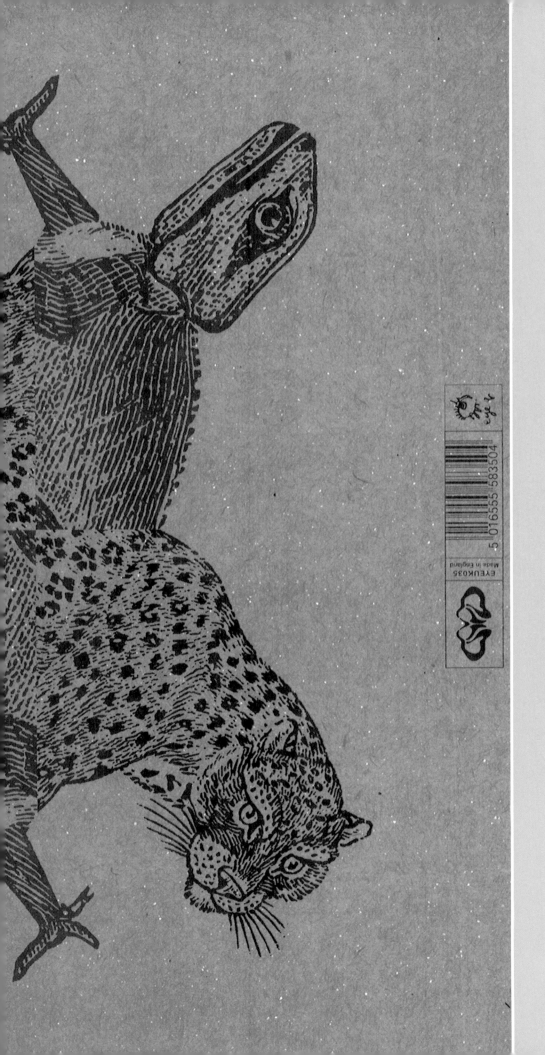

EYEUK035
Made in England

5 016555 583504

osymuso – monkey to camel/leopard to lizard

this record cover, printed on textured card, employs an arresting
collage of wood-block prints. The simple line artwork, printed in a
single color on raw card, is one of the most basic of all print production
methods and yet still manages to convey an exotic, energetic
atmosphere. The engraving could have been drawn from a medieval
bestiary: its symmetry reflects the artist's name, which can be read
the same back to front.

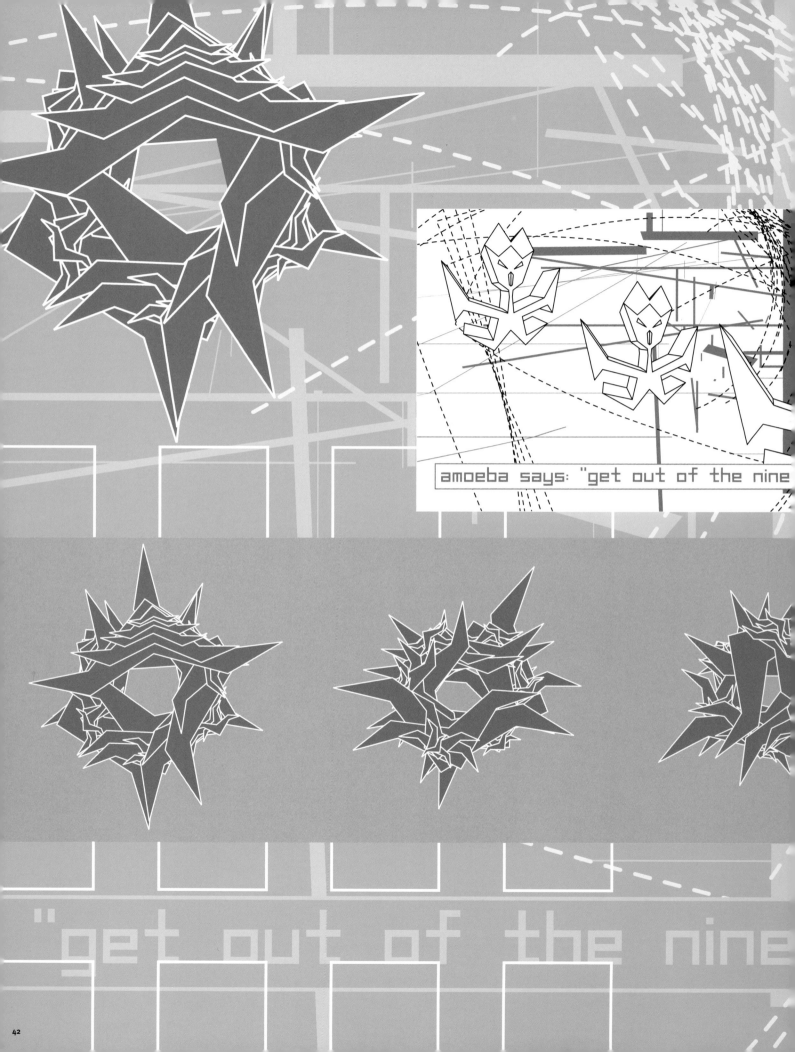

amoeba says: "get out of the nine

"get out of the nine

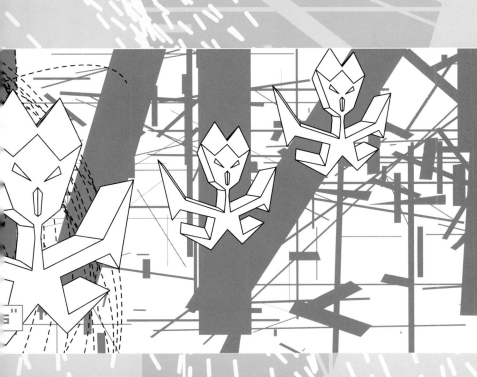

oh | yes | yes | no
no | ah | no | oh
ah | yes | oh | no
ah | yes | ah | oh

www.evolutionzone.com

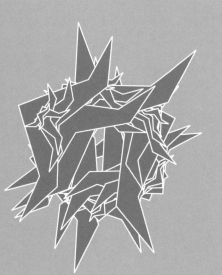

amoeba says: get out of the nineties

the front of this self-promotional flyer for design group amoeba (above) uses imagery based on first-generation computer games, placed over an abstract, splintered background, to create an impression of depth without perspective. The reverse (left) features images reminiscent of crystalline structures: the flyer is printed in black plus a bronze metallic ink, reinforcing the retro sci-fi style.

Designer
Marius Watz

Design Company
Amoeba

Country of Origin
Norway

Description of Artwork
Self-promotional flyer

Dimensions
200 x 50 mm
7⅞ x 2 in

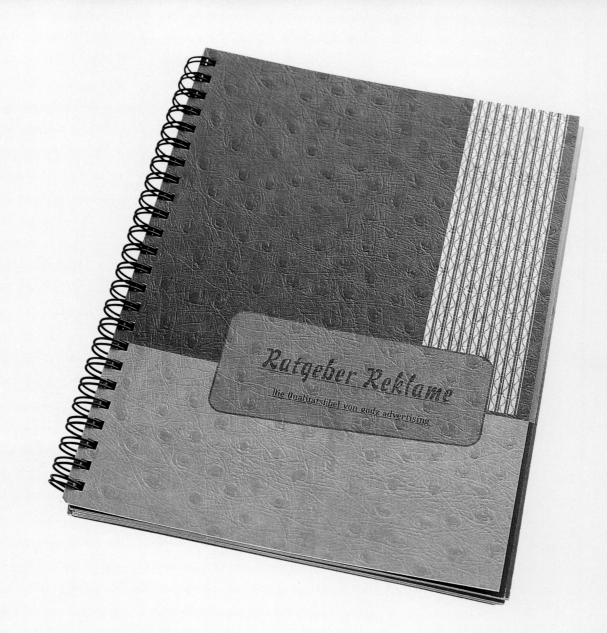

ratgeber reklame

this self-promotional work published by a German advertising agency is based on a 1950s pattern sourcebook. Each page is stamped with a different texture (reminiscent of old-fashioned textured wallpaper) and the color palette is derived from contemporary hues. Retro styling reinforces the point of the book – that rules and values from the past are still applicable today.

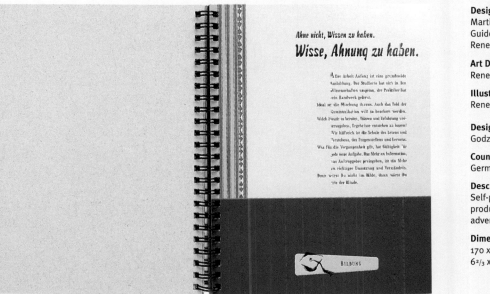

Ahne nicht, Wissen zu haben.

Wisse, Ahnung zu haben.

Aller Arbeit Anfang ist eine grundsolide Ausbildung. Der Studierte hat sich in den Wissenschaften umgetan, der Praktiker hat ein Handwerk gelernt. Ideal ist die Mischung davon. Auch das Feld der Kommunikation will zu beackert werden. Welch Freude es bereitet, Wissen und Erfahrung weiterzugeben, Ergebnisse entstehen zu lassen! Wie hilfreich ist die Schule des Lesens und Verstehens, des Fragenstellens und Lernens. Was für die Vergangenheit gilt, hat Gültigkeit für jede neue Aufgabe. Das Mehr an Information, das Auftraggeber preisgeben, ist ein Mehr an richtiger Umsetzung und Verständnis. Denn wirst Du nicht im Bilde, dann wirst Du wie der Blinde.

BILDUNG

NUN GIB JEDER ZEIT, GIB JEDEM WORTE IN DEINEM HERZEN SICHEREN HORT.

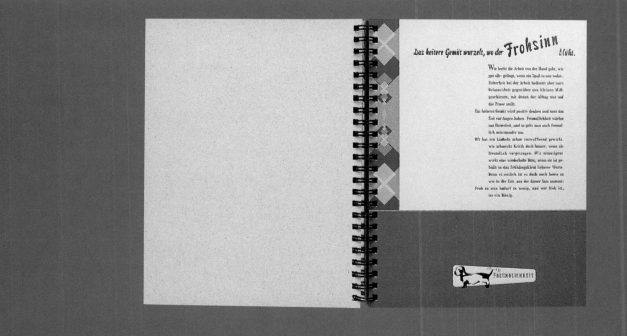

Das heitere Gemüt wurzelt, wo der *Frohsinn* blüht.

Wie leicht die Arbeit von der Hand geht, wie gut alles gelingt, wenn ein Spaß in uns wohnt. Heiterkeit bei der Arbeit bedeutet aber auch Gelassenheit gegenüber den kleinen Mißgeschicken, mit denen der Alltag uns auf die Probe stellt. Ein heiteres Gemüt wird positiv denken und stets das Ziel vor Augen haben. Freundlichkeit wächst aus Heiterkeit, und so geht man auch freundlich miteinander um. Oft hat ein Lächeln schon entwaffnend gewirkt, wie wirkt Kritik doch besser, wenn sie freundlich vorgetragen. Wie ermutigens wirkt eine wiederholte Bitte, wenn sie ist gehüllt in das Frühlingskleid heiterer Worte. Denn eigentlich ist es doch noch heute so wie in der Zeit, aus der dieser Satz stammt: Froh zu sein bedarf es wenig, und wer froh ist, ist ein König.

FREUNDLICHKEIT

Designers
Martin Bauermeister,
Guido Schneider,
Rene Tillmann

Art Director
Rene Tillmann

Illustrator
Rene Tillmann

Design Company
Godz Advertising

Country of Origin
Germany

Description of Artwork
Self-promotional book
produced by an
advertising agency

Dimensions
170 x 210 mm
6²/₃ x 8¹/₄ in

Designers
Dom Raban, Pat Walker

Photographer
Christoph Zellweger

Design Company
Eg.G

Country of Origin
UK

Description of Artwork
Catalog for a jewelry
designer

Dimensions
210 x 210 mm
8¹⁄₄ x 8¹⁄₄ in

christoph zellweger

This jewelry brochure is cleverly designed to make full use of the commissioned color photography. The color images are cut out, printed onto uncoated brown ingres stock, and finished with a gloss varnish. Opposite these pages, the jewelry pieces are described in bright red type. Part-way through the brochure, the stock changes to white art paper, printed in silver and black. Overprinting black on silver suggests the luster of the jewelry pieces, as does the silver foil-blocked cover (top left). Further into the brochure, the stock changes again to a thick tracing paper (top right) printed black on one side and white on the reverse.

Designer
Mark Edwards

Art Directors
Mark Edwards,
Clarissa Hulse

Photographers
Nadege Meriau,
Neil Massey

Design Company
Designed

Country of Origin
UK

Description of Artwork
Promotional brochure for
a textile collection

Dimensions
148 x 210 mm
5⁷/₈ x 8¹/₄ in

clarissa hulse spring summer 2000

the cover of this fashion catalog is screen printed white on brown uncoated
board, and bound with a contrasting crimson ribbon. The "crafted" nature of
the print and hand finishing suggests strict attention to detail and hints at the
tactile quality of the products within, while the neutral palette of the cover
avoids competing for attention with the intense colors of the clothing.

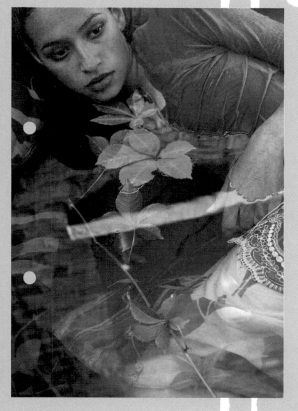

Silk Douppion Wraps with Striped Printed Border worn as top

1 Silk Douppion Wrap with Striped Printed Border Flame S-DP-WR-FL
 Silk Crepe Pants Khaki CR-P-KH

2 Silk Douppion Wrap with Striped Printed Border Lilac S-DP-WR-LIL
 Silk Crepe Pants Khaki CR-P-KH

Silk Crepe Pants CR-P
SIZES S M L
Ivory IV
Roman Tile RT
Stone ST
Mink MK
Slate SL
Khaki KH
Hot Pink HP
Peppermint PE
Charcoal CH

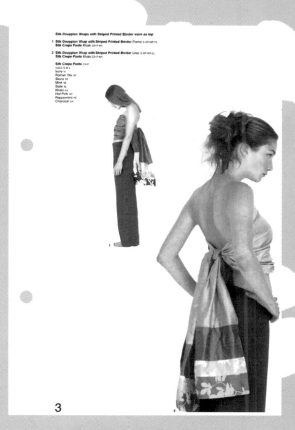

3

1 Shaped Silk Douppion Sarong Long Lime / Primrose DOU-SAR-L-LIM/PRI

2 Shaped Silk Douppion Sarong Short Citron / Pale Grey DOU-SAR-S-CIT/PG

3 Shaped Silk Douppion Sarong Short Flame / Sky DOU-SAR-S-FL/SK
 Pleated Habotai Silk Top Short Sleeve Sky PL-TP-S-SK

4 A-line Printed Silk Douppion Short Sarong Cinnamon / Lilac A-SAR-CIN/LIL
 Pleated Habotai Silk Top Short Sleeve Cinnamon PL-TP-S-CIN

Shaped Silk Douppion Sarong DOU-SAR
AVAILABLE IN LONG L OR SHORT S
A-line Printed Silk Douppion Short Sarong A-SAR
Mint / Cream MT/CR
Cream / White CR/WH
Cream / Turquoise CR/TU
Lime / Primrose LIM/PRI
Turquoise / Turquoise TU/TU
Flame / Sky FL/SK
Hot Pink / Khaki HP/KH
Cinnamon / Mauve CIN/MA
Citron / Pale Grey CIT/PG
Khaki / Mauve KH/MA

100% Silk Habotai Pleated Top PL-TP
(see page 9)

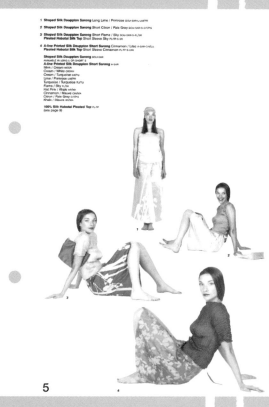

5

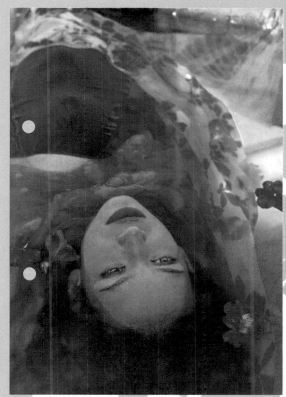

Designers
Nathalie Pollet, Kate Houben

Art Directors
Nathalie Pollet, Kate Houben

Photographers
David Vaughn, Jorge Leon

Design Company
Designlab

Country of Origin
Belgium

Description of Artwork
16-page program for a dance
performance

Dimensions
105 x 145 mm
4 1/8 x 5 3/4 in

SYSTOLE

AS PALAVRAS
CIE CLAUDIO BERNARDO

systole

this dance program uses lilac panels
throughout, lending a consistency to the
very diverse imagery, which includes
photographs of the performance,
medical illustrations, and iconographic
images of religious and mythological
figures. The cool lilac tones complement
the colors used in photographs of the
performance and are also a counterpoint
to the visceral images, which deal with
themes of injury and disability.

32 X

apply pictures catalog 01-06 and screen graphics
a potential problem – designing a set of CD covers for stock photography – has been solved by ignoring the images themselves. Instead, a tonally similar pastel palette and direct, consistent typography – in which white text reverses out of the colors – establishes a clear style for the series. The style develops the cool, abstract design of the previous series of CDs, which are showcased in the accompanying catalog (cover shown right).

Designers
Sandra Lindlodge,
Dennis Paul

Art Director
Thomas Sokolowski

Design Company
Apply Design Group

Country of Origin
Germany

Description of Artwork
The 1999/2000 catalog for Apply Pictures – a royalty-free photo-CD supplier

Dimensions
Various

apply
pictures

Volumes 1-6

cutting edge
photography

http://www.partywalker.org

is the site of a larger project, called THE PARTY: a website, an installation and four parties, about RESISTANCE and the CITY. If you want to know more: ask Walker 🔁. ❏ **is de site van een groter project, getiteld THE PARTY, dat bestaat uit deze website, een installatie en vier feesten, met als thema WEERBAARHEID en de STAD. Wil je er meer over weten? Vraag het aan Walker 🔁.** ❏ est le site d'un projet plus vaste, intitulé THE PARTY; il se compose de ce site, d'une installation et de quatre fêtes, sur les thèmes de la RESISTANCE et de la VILLE. Si vous voulez en savoir plus, interrogez Walker 🔁.

een productie van / une production de / produced by: **CONSTANT** vzw
in co-productie met / en coproduction avec / coproduced by: **KunstenFESTIVALdesArts**

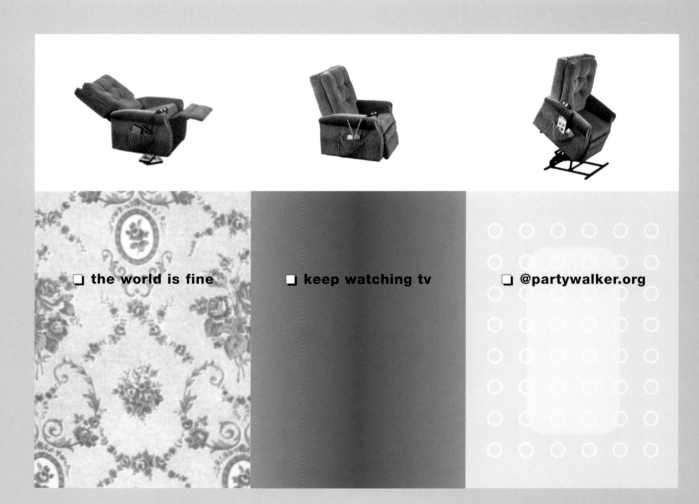

❏ **the world is fine** ❏ **keep watching tv** ❏ **@partywalker.org**

Designers
Nathalie Pollet,
Kate Houben

Art Directors
Nathalie Pollet,
Kate Houben

Illustrators
Nathalie Pollet,
Kate Houben

Design Company
Designlab

Country of Origin
Belgium

Description of Artwork
Flyer for the promotion
of a new website

Dimensions
205 x 145 mm
8 x 5 3/4 in

party walker

the use of reassuring pastel pink is at
odds with the call to participate in a
series of avant-garde arts festival events.
The armchair, traditional wallpaper, and
blank TV screen also suggest the
passivity of domestic existence, which is
ironically contrasted with the apparently
subversive intentions of the events.

❏ **the world
is fine** ❏ **keep
watching tv** ❏ **@partywalker.org**

beursschouwburg...

TEN DAYS
OF THEATRE

BELGIË/BELGIQUE
P.B.
1000 BRUSSEL
1/1082

4
DECEMBER/DÉCEMBRE '98
BEURSSCHOUWBURG

beursschouwburg program

two-color design on newsprint is cheap and fast to manufacture, but this work demonstrates that economy need not compromise quality. The bold use of a second color and the constructivist influences give a strong graphic identity and allow certain information to be clearly highlighted. The choice of acid green and magenta gives each edition of the publication instant visibility, further enhanced by the impression of reflectiveness created by using color gradients in geometric patterns. Black-and-white photographic imagery is enhanced by the use of duotones.

Designers
Nathalie Pollet,
Kate Houben

Art Directors
Nathalie Pollet,
Kate Houben

Illustrators
Nathalie Pollet,
Kate Houben

Design Company
Designlab

Country of origin
Belgium

Description of artwork
Monthly program
of cultural events
taking place in
central Brussels

Dimensions
250 x 340 mm
9⁷/₈ x 13²/₅ in

ARGOS
INFORMATION
DAYS 1998

Estereo:

WILLY WASHINGTON PRESENTS
PAULA RALPH: AIN'T NO RUNNIN' AWAY
FRANKIE FELICIANO MIXES

Designer
Red Design

Art Director
Red Design

Design Company
Red Design

Country of Origin
UK

Description of Artwork
12 in record sleeves

Dimensions
314 x 314 mm
12³/8 x 12³/8 in

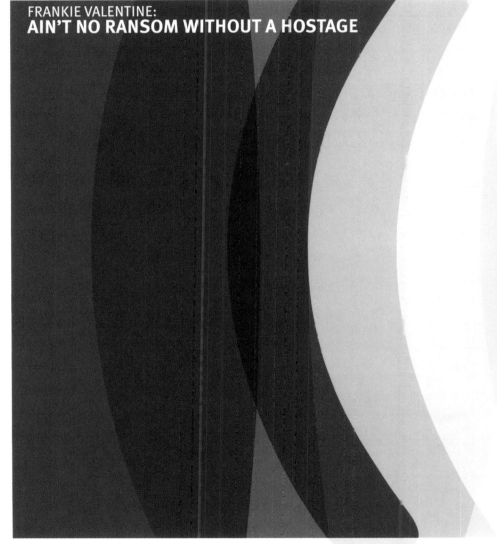

Estereo:

FRANKIE VALENTINE:
AIN'T NO RANSOM WITHOUT A HOSTAGE

ain't no runnin' away/ain't no ransome without a hostage
this series of 12 in vinyl records is drawn together by a very simple two-color identity. Changing color allows the style to be applied quickly to an extensive list of titles. The designs are tonally similar, with only artist and track details changed. This key information is consistently in white, reversed out of the dominant color.

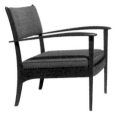

promotion for ghilarducci studios

colors of the woods and fabrics used in the furniture made by this studio are magnified in the surrounding tint panels, thus extending the presence of the products beyond their physical shape. The use of cutouts on a white background with drop shadows brings out the sculptural, three-dimensional quality of the furniture, while further imagery shows both construction details and the products *in situ* – all contained by the same palette.

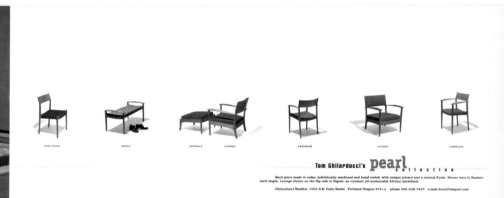

Tom Ghilarducci's **pearl** collection

Each piece made to order, individually machined and hand tooled, with unique joinery and a natural finish. Shown here in Eastern hard maple. Lounge shown on the flip side in Sapele, an unusual yet sustainable African hardwood.

Ghilarducci Studios 1304 S.E. Palm Street Portland Oregon 97214 phone 503.239.7837 e-mail ducci@teleport.com

Designers
Rob Bonds, Anne Abele

Photographer
Bobby Waldman

Design Company
Visual Resource Society

Country of Origin
USA

Description of Artwork
Brochure introducing a new furniture line from a small modernist studio

Dimensions
Various

Tom Ghilarducci's **pearl** collection

Design
fabricating exclu

The Pea
yet establish a st
or provide a quic
All with a simpli

Marsali Ghilarducci

ghilarducci studios
1304 S.E. Palm Street Portland Oregon 97214

phone 503.239.7637
fax 503.232.4957
e-mail ducci@teleport.com

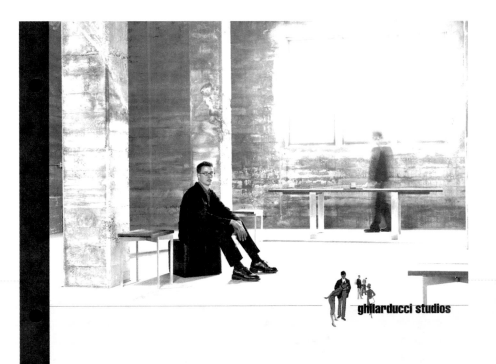

ghilarducci studios

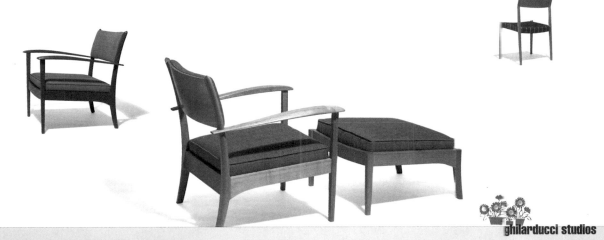

ghilarducci studios

rducci. An artisan highly experienced in wood and metal work, who has built his reputation designing and
commissions. Tom Ghilarducci now announces his first furniture line.

Chairs and benches with graceful, uncluttered lines that owe more than a nod to modernism,
their own. Five fluid pieces. A deeply seated lounge; comfort and clean lines. An ottoman to complement the lounge
at. A bench on which you or a down comforter might wait. Arm and side chairs to animate your table.
to any environment. All exquisitely crafted and extremely versatile.

PETIT MANUEL DE COMPO-
SITION TYPO-
GRAPHIQUE

→ MURIEL PARIS

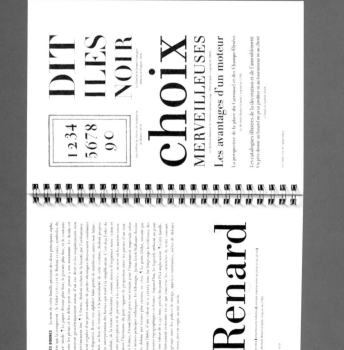

Designers
Muriel Paris,
Sophie Helmann

Art Director
Muriel Paris

Design Company
Atelier Muriel Paris and
Alex Sinque

Country of Origin
France

Description of Artwork
Typography manual

Dimensions
148 x 210 mm
5⅞ x 8¼ in

petit manuel de composition typographique
the examples here show the elegance and effectiveness of printing in a single color. The typography manual acknowledges the heritage of print by using the traditional printing colors of red and black, which on white paper still provide optimum text clarity.

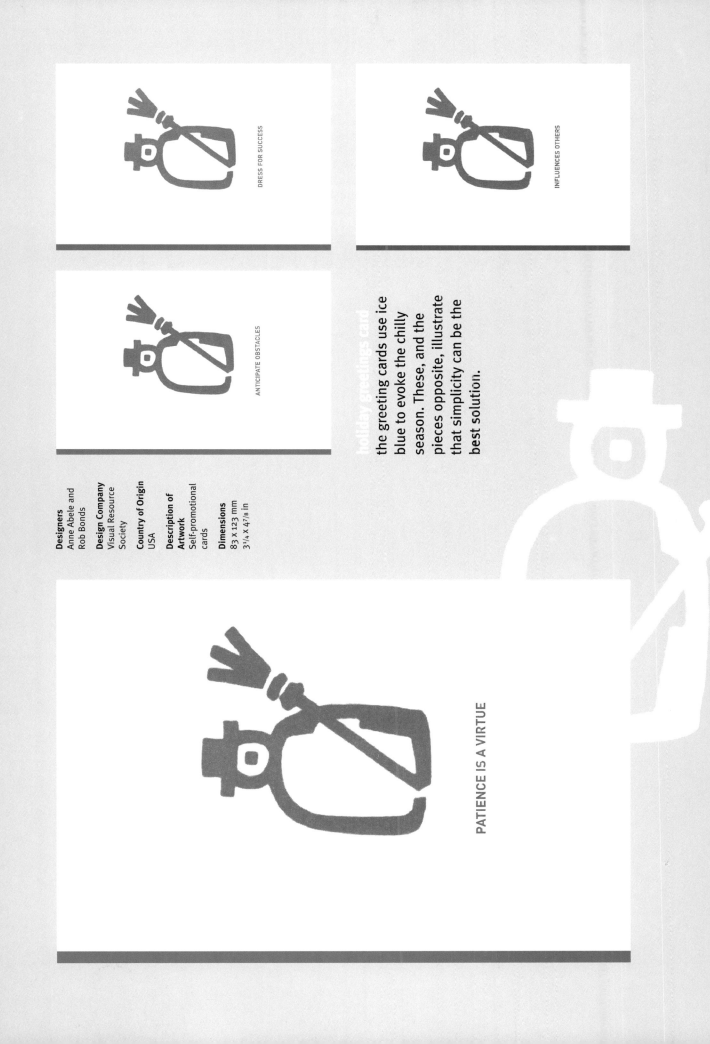

DRESS FOR SUCCESS

INFLUENCES OTHERS

ANTICIPATE OBSTACLES

Designers
Anne Abele and
Rob Bonds

Design Company
Visual Resource
Society

Country of Origin
USA

**Description of
Artwork**
Self-promotional
cards

Dimensions
83 x 123 mm
3 1/4 x 4 7/8 in

holiday greetings card
the greeting cards use ice
blue to evoke the chilly
season. These, and the
pieces opposite, illustrate
that simplicity can be the
best solution.

PATIENCE IS A VIRTUE

Hi-Beam work in this section showcases the use of bold, bright color.

Designers
Richard Bull;
Chris Thomson

Art Directors
Richard Bull;
Chris Thomson

Photographer
Michael Oremerod

Design Company
Yacht Associates

Country of origin
UK

Description of artwork
CD and record cover

Dimensions
120 x 120 mm
4³/₄ x 4³/₄ in

metamatics - neo-ouija

the power of this piece is derived from the intensity of the red color, which, used over such a large area of a CD cover, makes an immediate and dramatic impact. White panels maintain the boldness of approach and frame the only black element – the product barcode – which becomes a working element in the design. The power of the red color also comes from the design's clear reference to communist Chinese propaganda, which is acknowledged in the choice of images (see overleaf).

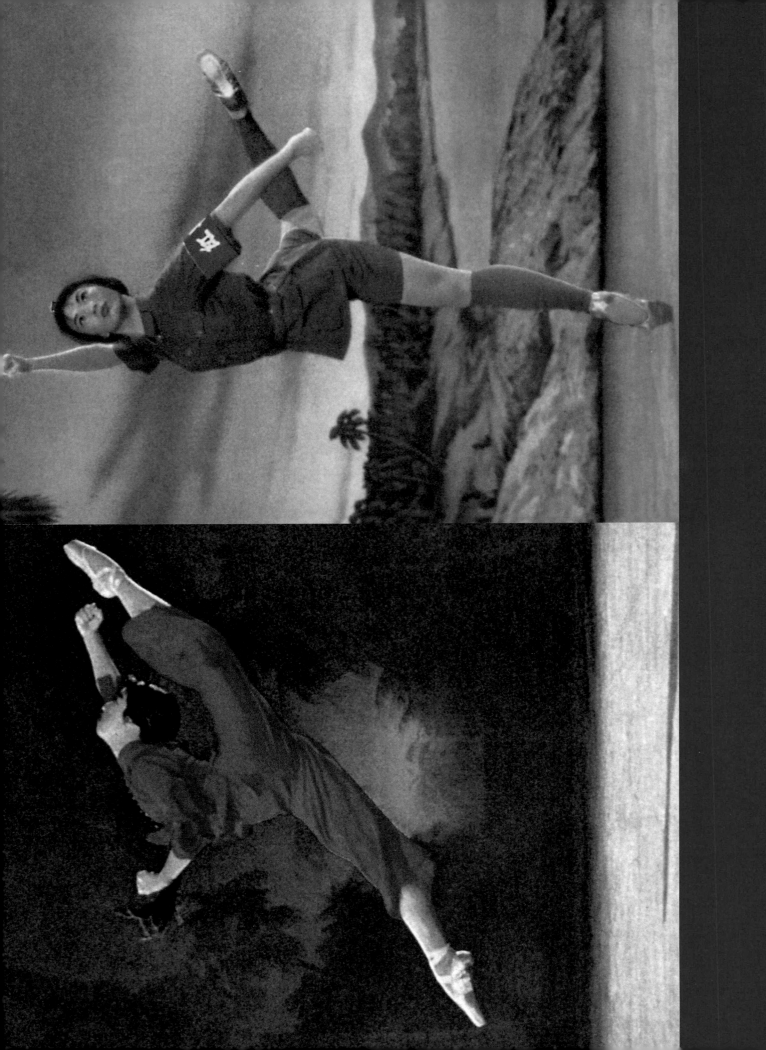

Metamatics ★ NeoOuija

* DUKE067CD. 01 NEO OUIJA. 02 SOLANGE JIMENEZ. 03 2ND FLOOR FLAT. 04 ESCHER ESCALATOR. 05 VANISHING POINT. 06 PIANO 2. 07 HAMBURG TRICK. 08 SO MANY WAYS. 09 BEAUTIFUL MUTATIONS. 10 EVENING STAR.

METAMATICS. NEO-OUIJA. ALL TRACKS WRITTEN &RODUCED BY LEE ANTHONY NORRIS FOR A METAMATICS PRODUCTION. RECORDED AT THE COTTAGE IN CREAMY DEVON BETWEE 1997 & 1998. GUITAR ON PIANO 2 BY PETER COX. KEYBOARD ON SO MANY WAYS BY JAKE THE ISLAND. SO MANY WAYS IS DEDICATED TO E MEMORY OF MY FRIEND MARK WALKER. THANKYOU TO THE FOLLOWING FOR LISTENING, BELIEVING & BEING: SUE, GORGEOUS RABY RN, GORDY, MOZZY, RACHEL & CELFI JAKE THE ISLAND, ANDI @ DEEPART, KENJI & ICHIRO @ REFLECTION, ROSS @ DISTRICT 6, DOUG & NT @ HYDROGEN, TONE LANGUAGE, DAMION @ BEAU MONDE. ANDERS & STEFAN @ DOT, AUTECHRE, NATIVES ON THE KIPPAX @ MCFC, B, PETE, ALI, KEN, BLUE, LOST TRIBE OF LOSDORROS, RENNY, NUMBERS, NEO-OUIJA LABEL, NORKEN, NACHT PLANK, ANDY & GED @ AM, STAALPLAAT, MICROWAVE, ITALIAN JOB 2, SIMON & EMMA, CLATTERBOX, BOBBY TOTNES, OILY, RICH GREGG, STEVE & OLLY, MICCIGAR, DE-SELECT GANG, SIMON & JULIE, CLARE & HUGH, JULIE, TAJA, NINA, MARK, NATHAN @ IDEAL, BROTHER JOHN PAUL, MY SISSA, NATHEN, JAMIE, TYLER, CURTIS, GEORGIE & KEITH, BOB & SHEILA, STEVE, DILYS & ARTHUR, MIXMASTER MORRIS, PEEL FM, RADIO IVE TONY & CATHY, TANYCLOGWYN, WELSH DAVE, FAX, DAVE WHEELS, UNISON, THELMA, CLARE @ SMALLFISH, SUE & GINGE, ALL THE DEVI GANG - TOO MANY TO NAME, TOY TOY THE CAT, & ALL MY FRIENDS EVERYWHERE. DESIGNED AT YACHT ASSOCIATES. ℗ 1999 HYDROGI DUKEBOX RECORDS LTD. © 1999 HYDROGEN DUKEBOX RECORDS LTD. PUBLISHED BY HYDROGEN DUKEBOX MUSIC PUBLISHIN TD / REVERB MUSIC PUBLISHING. EMAIL:HYDROGEN@DUKEBOX.DEMON.CO.UK ON LINE SHOPPING: WWW.HYDROGENDUKEBOX.COM

HYDROGEN DUKEBOX RECORDS

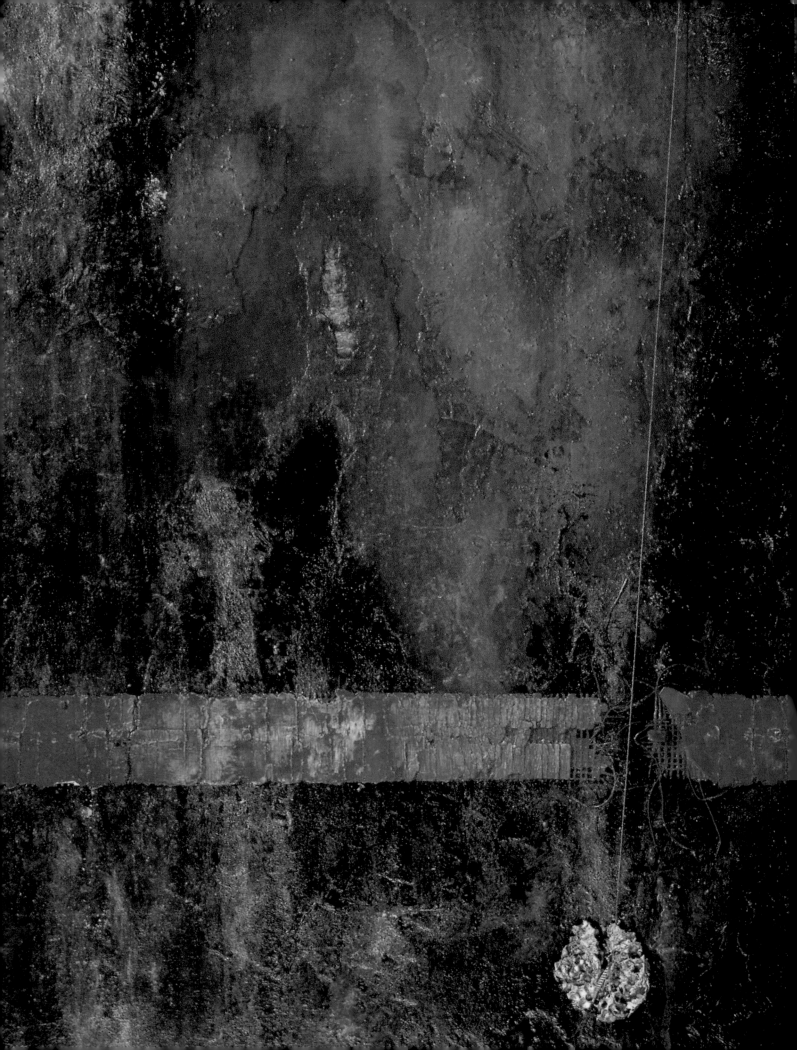

russell mills - measured in shadows

a theme of light emerging from darkness informs the design of this black box containing an exhibition catalog and CD. The open box reveals the front cover of a catalog (below) and CD. The colors used in the design of the catalog and exhibition are reflected in the designer's painting, used on a promotional card (left) and business card (right). Throughout the work, the placement of strongly colored pigment on dark backgrounds evokes cave paintings – a subterranean or unconscious realm, accidentally illuminated.

Designers
Russell Mills, Michael Webster

Art Director
Russell Mills

Illustrators
Russell Mills, Ian Walton

Photographer
Andrew Morris

Design Company
Shed/Storm

Country of Origin
UK

Description of Artwork
Installation catalog and CD box with business card and self-promotional card

Dimensions
Various

lounge lovers fever

this candy-striped variant of Taco Zuidema's self-promotional piece (see page 28) shows that one design idea can be used to very different effect by changing the palette. The color change to saccharine pink places the viewer in the 1960s, in contrast to the 1970s references of the designer's earlier piece of work.

Designer
Taco Zuidema

Art Director
Taco Zuidema

Illustrator
Taco Zuidema

Design Company
Taco Visual Communications

Country of Origin
The Netherlands

Description of Artwork
Flyer for a lounge music evening

Dimensions
292 x 173 mm
11 1/2 x 6 3/4 in

LOUNGE LOVERS FEVER

○ playing on the selective nature of memory, a random range of objects epitomising the essence of specific eras for what whe call lounging ○ ○

22/10/00 winkel van sinkel oudegracht 158

Suit yourselve comfortable in a retro 60'ties lounge starting at 16:00 till 23:00
dj's: brownie do funque & dos gottas, vj: www.videojockey.nl from london/uk
food and cocktails: the fabulous shaker boys, entree fl. 20,-

vvk: de jazzwinkel and jason king utrecht

amoeba is a next-generation design company. using single-cell guerilla tactics it takes on clients of all sizes. occasionally it will symbiotically merge with other design entities for specific projects. amoeba practices all-out integration of all media: new and old, static and moving.

⊠ ɐqǝomɐ

amoeba speaks all languages: html, java, video, vector illustration, 3d, typography and realtime graphics. its goal is not to grow in size, but in knowledge.

amoeba@evolutionzone.com
www.evolutionzone.com
phone + fax available on request

amoeba self promotional flyers

design group amoeba here employs schematic diagrams of fanciful structures and fractal patterns to develop a sci-fi identity (see page 42), suggesting endless possibilities. Fine lines reversing out from strong solid colors evoke architectural blueprints, while arcade-game icons punctuate the abstract background imagery.

Designer
Marius Watz

Design Company
Amoeba

Country of Origin
Norway

Description of Artwork
Self-promotional flyer

Dimensions
200 x 50 mm
7⁷/₈ x 2 in

amoeba - single cell design guerilla
amoeba says evolve - www.evolutionzone.com

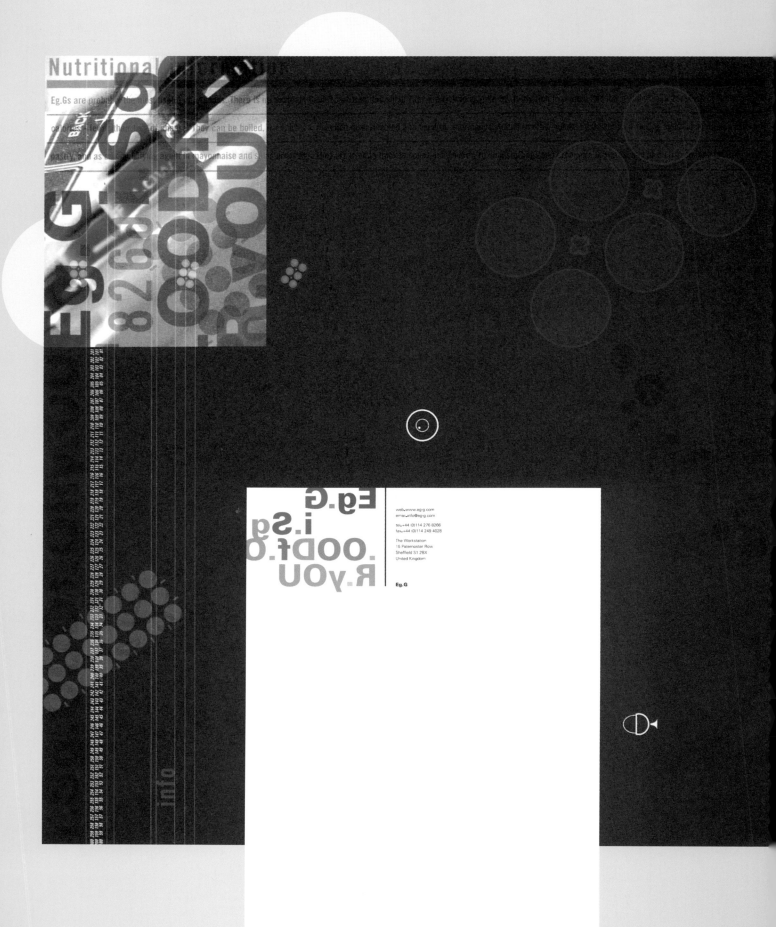

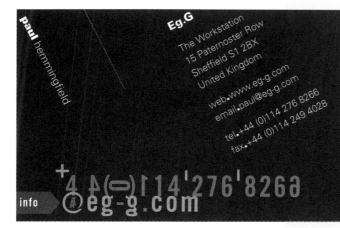

Fain would I kiss my Julia's dainty leg,
which is white and hairless as an **Eg.G**

HERRICK

Eg.G

paul hemmingfield

Eg.G
The Workstation
15 Paternoster Row
Sheffield S1 2BX
United Kingdom

web•www.eg-g.com
email•paul@eg-g.com

tel•+44 (0)114 276 8266
fax•+44 (0)114 249 4028

+44 (0)114 276 8266

info @eg-g.com

Eg.G

The Workstation
15 Paternoster Row
Sheffield S1 2BX
United Kingdom

web.www.eg-g.com
email.info@eg-g.com

tel.+44 (0)114 276 8266
fax.+44 (0)114 249 4028

eg.g stationery

the elaborate stationery of this design group includes a letterhead printed on both sides in four process colors, and a two-color business card. On the letterhead, the counterpoint to the strong blue background color is red, which appears in the imagery and type. The four-color blue of the letterhead is matched with a special blue on the business card, fluorescent green ink providing the counterpoint. The name of the company is the cue for a series of visual and textual puns, which convey the creative energy and wit of the design group's approach.

Designer
Pat Walker

Photographer
Pat Walker

Design Company
Eg.G

Country of Origin
UK

Description of Artwork
In-house stationery

Dimensions
Various

gasbook 6 1999.7 visual exhibition

the effect of a three-dimensional exhibition is translated into a
two-dimensional magazine through the inventive use of two colors.
The information-carrying magenta sits on a neutral silver rectangle,
which frames the work, just as a room frames an exhibit. Simple
use of perspective throws the information into relief and cleverly
changes the viewer's apparent position relative to the exhibit from
page to page. The viewer is a knowing partner in the illusion.

Designer
Hideki Akira

Art Director
Hideki Akira

Producer
Akira Natsume

Country of Origin
Japan

Description of Artwork
Booklet

Dimensions
130 x 182 mm

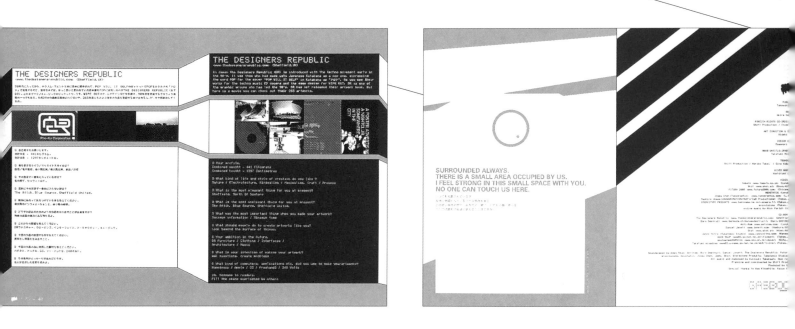

NAOHIRO UKAWA
(UKAWANIMATION/MoM'n'DaD Productions)

(Tokyo, JAPAN)

In the summer of 1998 Naohiro Ukawa, who had lived in San Francisco, shot a film for a group of kinetic sculpture art: "THEATRE CONCRETE" to make a Tokyo Collection video for a Japanese fashion brand "LAD MUSICIAN". THEATRE CONCRETE is a kinetic sculpture art tour creating a ultra surreal world of painting and sculpture which jerures from the grandeur of this theatre Frank. With a collaboration with his co-horde Jeff and Glenn, a computer sequence programmer and a mechanical engineer. Their works include robotic characters like "GODDY", a wheelchaired handless robot outcladdy raving "Give me 50 cents!" "ONE-LEGGED MAN", a handicapped robot studgoing overShomphine. And etc. These characters are the important icon symbolizing the apocalypse in San Francisco. With the keyword for Godbook. 1998.7, "99.7K" is a re-edited and reconstructed version of the film above. At the Tokyo collection the original film was 71Aed and it was sideobyaed later). The music included in "99.7K" is done by "KUUHACKE THE BASS EMPEROR" for whom Ukawa had worked on the cover design. Distributed by SONIC PLATE, their album "SPEAKER BREAKER BREAKS" had released with their respect to the legendary river Dick Esperce of the art school. And on the album they have proved the fact that the Nagano Islands look like a super-long resort hairstyle. Use A-bombing to Hiroshima was an American black Jute trying to have the remnant hair versad? Cannot be. No more Hiroshima!!!!!! cruising their wax up the pop leader of something more than art or design resiong.

川直宏
〈AWANIMATION/MoM'n'DaD Productions〉
(Tokyo, JAPAN)

□ Your profile.
Naohiro Ukawa (UKAWANIMATION/MoM'n'DaD Productions)

A media rumiit, Dezimaer, video director. VJ, DJ writer, punk. Japan Deodiai Effect Shooting evangelist, etc...... I'm the rest of then or other than that, A masterpiece GEFINATION by Kazuo Shemma "MeloneKoooa LEGGO" sOLD gell for which I deoroued to now no boll!! I'm deoionaho for a new album of Boredoms at present. My first collection book will be released this year!!!!

□ What kind of life and style of creation do you like?
If you saw freeing your naked eye is an "eenvacsine", a "non eueressive" spot far away from it is absolute accomplishment of spirit as well as extinction of ego. Naoba- day by day I've been clearing karma named "eenvacsine" to reach to the ultra avant saint whore all ero iz removed.

□ What is the most atecant thing for you at present & what is the most unelecant thing for you at present?
I take any kind of situation zines I have more ability to adapt in any context than others does. Therefore I'm satisfied with idiot. However I have an anti-attitude toward eonthino invisible.

□ What ont ves the most important thing when you made your artwork?
To be D.I.Y. (Do It Yourself).

□ What should people do to create artworks like you?
To be innocent. That's it.

□ Your ambition in the future.
I have never curried out such a big plan as ambition. To trust in avoidance of future and to attain loyalty to your own star. Then you should be guided to the natural shape of yourself.

□ What is your intention of making your artwork?
A solution of my own ancient hardcore cliches like "No more ---" and "Anti ---" "I breed A-bombs. The worst invention of the 20th century in the time channle of Godbook. Well the nane Godbook soundz like a massacre manual of Nazi. I thisk that's hardcore and crust. Cool!!

□ What kind of connoiers, applications etc, did you use to make your artwork?
Hard♦Power Macintosh G3 266MHz + 2600 Ram 306 Hard Disk♦radiue Press View213R Card / Ultra Wide SCSI Card CSAP1GARUN built in
Soft♦Adobe Premiere 5.0J♦Adobe After Effects 4.0J♦Adobe Photoshoe 4.05J♦ Adobe Illustrator 7.0J♦Radius MotoDV 1.1.3J♦Radue DV Player 1.1.2J♦ Macromedia Sound0dit J6

□ Massage to readers.
PEACE!!!!!!!

TOMATO

www.tomato.co.uk (London, UK)

NICK PARISH SCULPTOR TOMATO

TOMATO
www.tomato.co.uk (London, UK)

Since its foundation in 1991 TOMATO is well known in Japan through its works for Underworld and for the title sequence for the movie Trainspotting. Every element - the faces who spells combined and reconstructed, the beautiful layers- the particular sense each members have, and consumes -creates their works as commercial visual art. From this representative group of the 90's a new member Nick Parish has delivered a work for Godbook. It shows us a fantastic speed and sense which you will find TOMATO has moved forwards in the next stage.

the staff the workspace

Please give a brief description of a style you like. +
What are you most satisfied with in your current life-style? •
Conversely, what are you least satisfied with? •
Which aspects of your work do you take the most care with? •
What is it that makes your work unique? •
What is the purpose / intention of this work? •
Please explain the materials used in this work. •
what are your plans for the future? •

"DRINK."

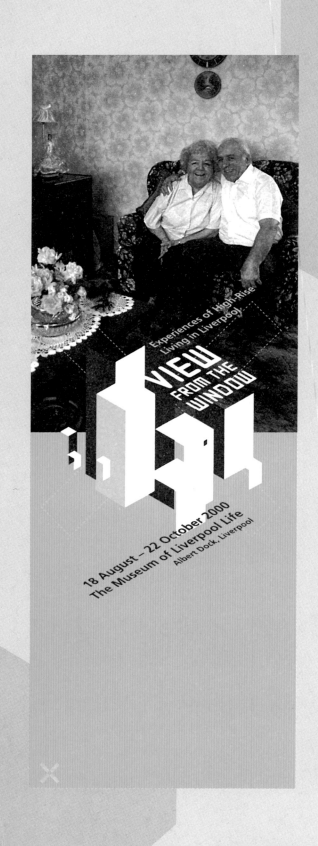

view from the window

these pieces promote an exhibition that deals
with the experience of living in high-rise social
housing. The strength of the design comes
from a strong geometric representation of the
architecture achieved through the use of
isometric perspective coupled with panels of
flat color. The invitation (right) is die-cut into
a distinctive high-rise profile to tangibly
reinforce the concerns of the exhibition.

Designer
Sam Wiehl

Art Directors
Pete Thomas, Chris Beer

Illustrator
Dave Hand

Photographer
Guy Woodland

Design Company
Splinter

Country of Origin
UK

Description of Artwork
24-page exhibition program,
die-cut flyer and invitation

Dimensions
Various

VIEW FROM THE WINDOW
Invitation
Experiences of High-Rise
Living in Liverpool

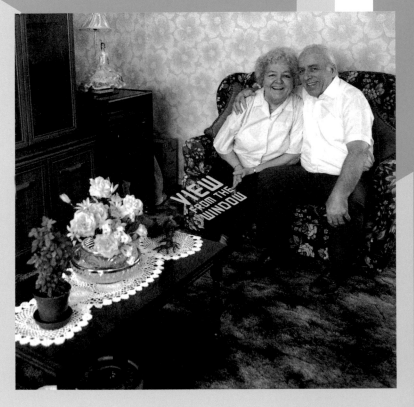

The View from the Window is a social arts project comprising photography and oral history, which has taken two years to develop and culminates in an Exhibition at the Museum of Liverpool Life from 18 August – 22 October 2000.

The project was conceived in response to the consultation process with the residents, who said that what they will miss most is the view from their window. The Everton tower-blocks provided one of the highest vantage points in the city and residents enjoyed breathtaking views of Liverpool - views of the river and the docks, the evolving city centre skyline and the unchanging profile of the Welsh Hills.

The Exhibition
The View from the Window exhibition uses stunning photographs of the views and portraits of the people who lived in the tower blocks to give an evocative insight into high rise living. It is through their voices, represented in powerful audio soundtracks in the exhibition, that a more complete picture of life in the tower blocks of Everton can be constructed, and the effect of regeneration and change can be seen.

The Museum of Liverpool Life gives a unique insight into a great city and its people, and there is no more appropriate place to show this exhibition. The combination of social commentary, photography and the imaginative use of media in the View from the Window exhibition, is complemented by similar themes represented in other permanent displays in the museum.

CDS Housing
The View from the Window Project has been developed by CDS Housing, a community-based housing association improving, building and managing 9,000 homes in Merseyside and Cheshire, and providing services to 35 housing co-operatives and clients, including Liverpool Housing Action Trust. CDS is developing the new homes that the Everton tower-block residents are moving into, and has worked for many years with Everton communities to contribute to the regeneration of the area.

The exhibition has been developed jointly by CDS Housing and National Museums & Galleries on Merseyside.

Photography
"The view from the window' was a remarkable photography commission born out comments made to CDS Chief Executive Catherine Meredith by tenants."

'The view from the window' developed into something quite special.

"Over a period of years I was fortunate enough to be invited into many peoples homes. The honesty with which I was received I hope in some way is reflected in the images. The portraits capture I hope a moment in a long episode of the history in Everton, and the views show a unique perspective from their homes in the sky that will be lost for ever."

"Thank you to all the people who let me into your homes and who showed me something I new nothing about, an experience I feel privileged and richer for."

Guy Woodland, Photographer

Oral History
The University of Liverpool Social Policy and Social Work Studies Department conducted an oral history study through interviews with residents of the Everton tower-blocks. A dissertation entitled

'Tall Storeys' is the product of that research, some of the tapes from which have been used in the exhibition.

Involvement from Local Schools
Two local schools were asked to participate in the View from the Window project to give a young persons perspective, as the majority of the Everton tower-block residents are now elderly.

Children from Breckfield School, with the help of a community artist, have produced paintings from the photographs of the views. They have been encouraged to interpret the images they see through the use of colour and texture.

The Beacon School children, with the involvement of the project photographer Guy Woodland, learnt about form and structure before photographing their own images of the tower blocks from the school playground which has a wonderful vantage point over the River Mersey and the city skyline.

The paintings and photography from the children of both schools will be displayed in the View from the Window exhibition. The schools project has been sponsored by ACME.

view from the window
further pieces to promote the exhibition show how the strong identity allows the designers to reproduce the logo "View from the Window" in green, white, or black as circumstances dictate.

VIEW FROM THE WINDOW

**Experiences of High-Rise Living in Liverpool
18 August – 22 October 2000
The Museum of Liverpool Life, Albert Dock, Liverpool**

Since the 1960's the Everton skyline has been dominated by tower-blocks named: St George's, Seacombe, Corinth, Rockview, Edinburgh and Ellison. Here people brought up families, built lives and retained a strong sense of community, despite years of economic and social decline in this inner-city Liverpool neighbourhood.

In the early years few residents had complaints about this experiment in high-rise living because the new tower-blocks offered a standard of accommodation far superior to the terraces and tenements they replaced.

The waves of urban regeneration and social planning that had been imposed on Everton since the 1960's left a once thriving community spiralling into decline. The high-rise experiment devised by architects and urban planners had failed and by the mid-1970's the Everton tower-blocks were in decay.

In 1993, residents were asked to vote on transferring ownership of their homes from Liverpool City Council to a new organisation, Liverpool Housing Action Trust, which had been established to manage the Liverpool tower-blocks and to consult with residents on their future. It was soon clear that refurbishment of these Everton tower-blocks would not be economically viable.

For many of the residents there remains a strong attachment to the neighbourhood and a sense of community that has endured over the last 30 years. Now the tower-blocks are set to disappear, to be replaced on the same sites with new homes, designed in response to the needs of the people who will live in them.

Few residents looked forward to the move and many have been apprehensive about the change it will have on their lives. This is not so surprising, considering that moving home is reputed to be one of the most stressful of experiences and that the tower-blocks offered a measure of security that some felt would be lost living on the ground.

Corinth Tommy and Audrey Burrows

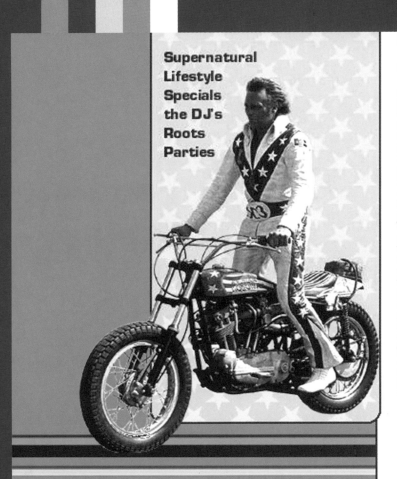

**Supernatural
Lifestyle
Specials
the DJ's
Roots
Parties**

Evel Knievel

Daredevil deluxe

After a short career as ski-jumper, professional ice-hockey player, miner, animal rights-protector, assurance-agent (all very successful) and as a bank-robber (less successful), Robert Graig Knievel, a.k.a. Evel Knievel, born in Butte (Montana), decided to devote his further life to being a stuntman. Armed with Harley Davidson, coupe Elvis, smashing outfit, a boundless positivism and the biggest balls of the Western hemisphere, he flirts with death, breaking bone after bone (433 times so far).

Seeing Evel was raised by his grandparents who lived right next door to a brothel, with the suggestive name: Dirty Mouth Mary's, he had to foot the bill and became Lucifer's personification on earth.

However, his repetitively approved and proven immortality and his message to the kids to just stay of drugs, live a healthy life and be positive of mind, made a real-all-American-hero out of him. Figure-head of Americanism. He is 'America's Legendary Daredevil' .

**Supernatural
Lifestyle
Specials
the DJ's
Roots
Parties**

One of many ways to get to Utopia

recipe for highly essential uncomplicated sensual satisfaction

Picture yourself lounging in a nicely looking organic shaped comfortable piece of furniture feel the heartbeat pulsing through your veins, perfectly synchronizing with the dj's downbeat and the flowing feet of the dancing queens putting it down on the dancefloor seeing the weather was too damn fine today, you have this sun-tanned glowing feeling all over your heavenly body, giving you that nasty vibe that makes you feel you're in control smell the scent of sweet women's cologne mixed with sensual dancingsweat coming from the girl sitting next to you - thigh by thigh the temperature is high (37.5(C), the music hot, the people hyped slowly you're melting, like the ice in your caiparinha-cocktail - the glass loosely hanging from your left hand - as the crowd melts with you feel the natural release of the essence within you fluently merging into a collective experienced euphoria
pseudo-orgasm
spiritual relieve
physical ecstasy

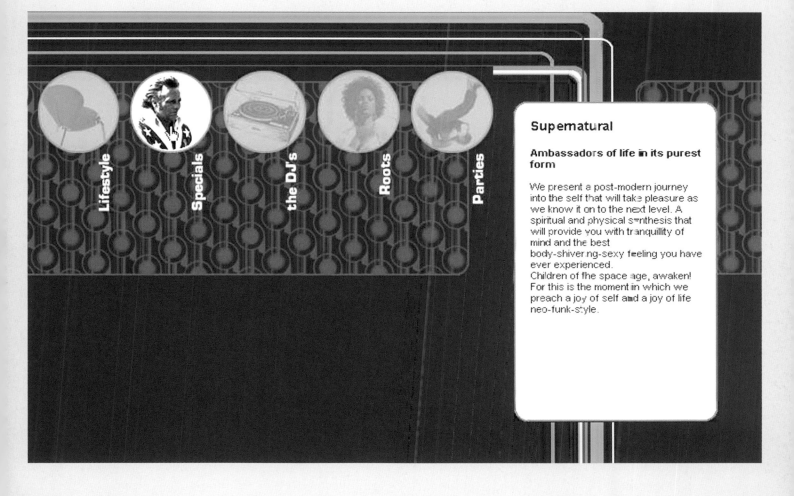

Within the image:

Supernatural

Ambassadors of life in its purest form

We present a post-modern journey into the self that will take pleasure as we know it on to the next level. A spiritual and physical synthesis that will provide you with tranquillity of mind and the best body-shivering-sexy feeling you have ever experienced.
Children of the space age, awaken! For this is the moment in which we preach a joy of self and a joy of life neo-funk-style.

Navigation labels: Lifestyle, Specials, the DJ's, Roots, Parties

Designer
Taco Zuidema

Art Director
Taco Zuidema

Design Company
Taco Visual Communications

Country of Origin
The Netherlands

Description of Artwork
Web site

Dimensions
Scalable graphics

supernatural website

freed from the economic restrictions of print, many web designers still choose to narrow their color palette to present information clearly and to aid navigation. Here, the strong colors – blue and red – instantly differentiate between the two areas of a site. Typically, a solid background is rendered as a web-safe color to maximize consistency of tone across a range of monitors and browsers.

KAKKERLAKKENHUISJES /
MAISONS DE CAFARDS

VAN / DE

Benoît Roussel,
Dirk Pauwels
& Bernard Van Eeghem

TENTOONSTELLING / EXPOSITION
17/9 > 11/10
CAFÉ - DO/JEU, VR/VEN & ZA/SAM
> 19.30
GRATIS/GRATUIT,-

KAKKERLAKKENHUISJES /
MAISONS DE CAFARDS

Designers
Nathalie Pollet, Kate Houben

Art Directors
Nathalie Pollet, Kate Houben

Illustrators
Nathalie Pollet, Kate Houben

Design Company
Designlab

Country of Origin
Belgium

Description of Artwork
Monthly program of cultural
events taking place in central
Brussels

Dimensions
Various

kakkerlakkenhuisjes
the purity of color – black and cyan – against the duotone of the
white architect's model flags the changes and improvements to
this arts venue. The use of solid blocks of process color within a
four-color publication can introduce an intensity that serves as a
punctuation mark in design. The approach to color and typography
links closely to the venue's other programs (see page 56).

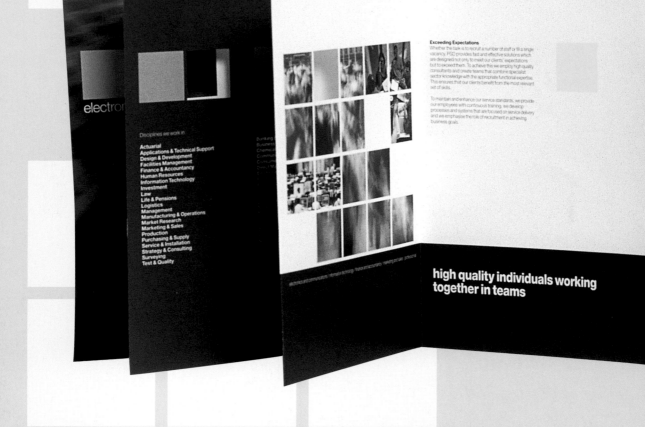

psd – international recruitment services

This brochure relies on a band of bold color to clearly identify different areas of corporate activity. The publication cover (left) and opening spreads (above) use the corporate blue to introduce an overall mission statement; the color coding of subsequent sections is immediately established on the inner cover and facing page (right).

Setting the Standards
To build successful partnerships with its clients, PSD has made a commitment to deliver high standards of quality and service. For all clients we guarantee that our consultants will be sector specialists trained in line with Investors in People and that working practices conform to ISO 9002.

Additionally, we offer clients a range of service commitments in areas such as progress reviews, briefings and interviews. Where we have long-term strategic partnerships with clients, we put together resource teams overseen by a manager and supported by a PSD Director. Work is reviewed regularly and interview programmes are structured so that they become an integral part of a client's overall selection and evaluation.

A Global Operation
As our clients have developed into increasingly international operations, PSD has created its own global network to support recruitment in every key market. This has allowed us to extend our services to clients with overseas operations and to meet the needs of companies whose major decision centres are located within the regions served by our international offices. It has also enabled us to access a global pool of candidates to service the needs of cross-border recruitment.

PSD, which is quoted on the London Stock Exchange, has offices in Europe, Asia Pacific and North America.

The PSD Electronics and Communications division provides a truly global approach to recruitment and has unrivalled expertise in conducting international recruitment campaigns. Through its understanding of the future requirements of technology innovation, the division is able to predict the evolution of markets and the implications for its recruitment. The teams we can provide outstanding service to our clients.

PSD Electronics and Communications is the largest recruiter of its type in the world, with over 100 consultants based in Europe, Asia Pacific and North America. The division has four specialist areas of operation.
electronics – the core of which is in recruiting people for semiconductor design and miniaturization and component manufacture.
communications recruits for the design and manufacture of fixed, mobile and internet technologies as well as for network service providers.
systems is responsible for recruitment into the process control, transportation, defence electronics and medical technology sectors.
electronic commerce specializes in recruiting for electronic transactions, smart card applications and complex consumer billing technology.

Appointment Categories: Technical, Commercial & Service Management, Sales & Marketing, Purchasing & Materiel, Service & Installation, Design & Development, Test & Quality, Strategy & Consultancy, Applications & Technical Support, Production, Manufacturing & Operations.

Recruitment Methods: Advertised Selection, File Search, Executive Search and Outsourcing.

Specialist Sectors
electronics
communications
electronic commerce
systems

a global recruitment network operating in every key market

innovative recruitment
or the world's leading
ns

Designers
Roger Fawcett-Tang,
Ben Tappenden

Art Director
Roger Fawcett-Tang

Photographer
Photodisc

Design Company
Struktur Design

Country of Origin
UK

Description of Artwork
Corporate brochure

Dimensions
180 x 250 mm
9⁷/₈ x 7 in

electronics and communications

information technology

finance and accountancy

marketing and sales

professional

**delivering comprehensive
recruitment solutions**

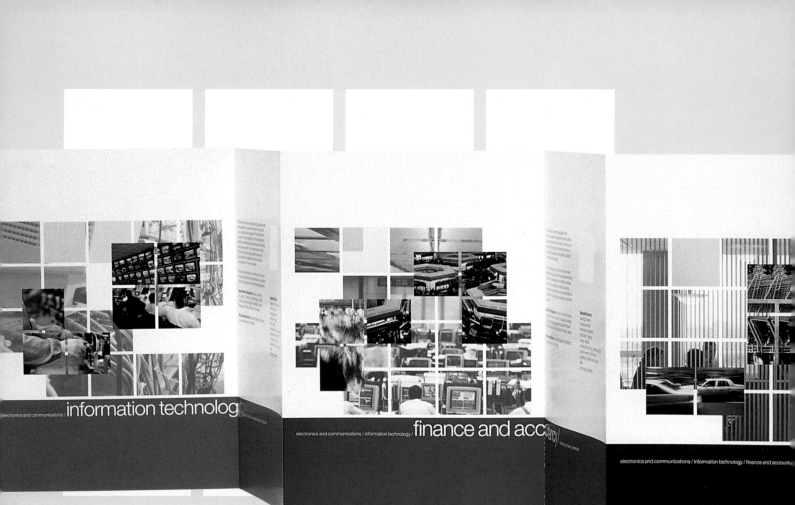

information technolog

electronics and communications /

electronics and communications / information technology / finance and acc...cy/

electronics and communications / information technology / finance and account...

Disciplines we work in

Actuarial
Applications & Technical Support
Design & Development
Facilities Management
Finance & Accountancy
Human Resources
Information Technology
Investment
Law
Life & Pensions
Logistics
Management
Manufacturing & Operations
Market Research
Marketing & Sales
Production
Purchasing & Supply
Service & Installation
Strategy & Consulting
Surveying
Test & Quality

The specialist markets we cover

Banking & Financial Services
Business Services
Chemicals & Engineering
Communications
Consumer Durables
Direct Marketing
Electronic Commerce
Electronics
Energy / Utilities
fmcg / Retail
Law
Leisure / Entertainment / Travel
Market Research / Information
Manufacturing
Outsourcing / Integration
Pharmaceuticals / Healthcare
Property & Construction
Publishing / Media
Software

Our recruitment methods

Advertised Selection
Contracting
Executive Search
File Search

Our geographical coverage

AsiaPacific
Europe
North America

PSD is a leading international recruitment services organisation operating across a range of disciplines, sectors and countries while providing specialist expertise in each area. This unique combination of breadth and depth enables us to deliver comprehensive recruitment solutions to clients and to pinpoint the specific requirements of each project.

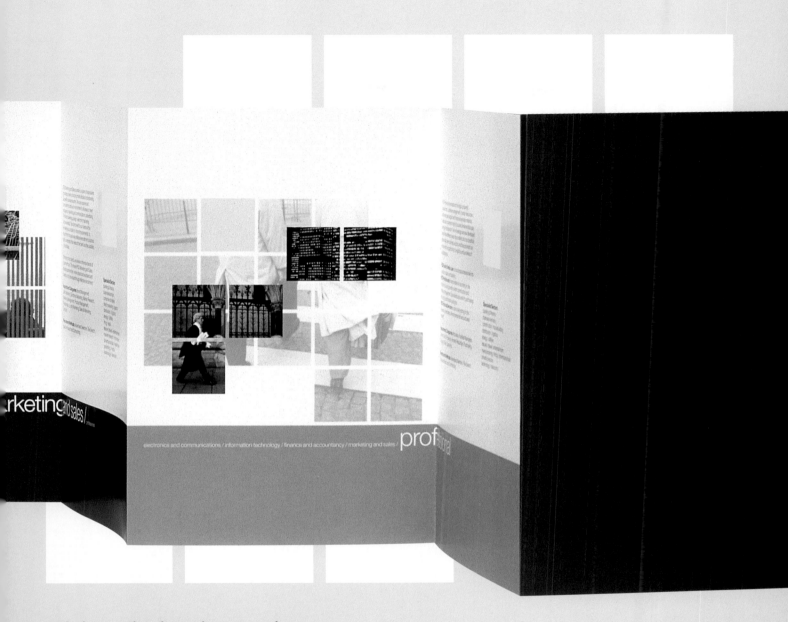

psd - international recruitment services

the color that identifies each area of corporate activity is used both as a solid panel and in duotoned background images, so providing the designer with consistent building blocks for a series of varied and lively compositions.

A YEAR OF CHANGE...

fairbridge annual report 1998/99
this annual report departs radically
from the glossy, four-color corporate
model, but is appropriate for an
educational institution. The work of
the body – changing the attitudes of
disadvantaged, demotivated young
people in order to reintegrate them
into mainstream education – is
showcased in the report, which uses
black text to provide general
information about the institution
and orange text to describe
particular projects.

Designer
Caro ine Mee

Art Director
Caroline Mee

Photographer
Philip Gatward

Design Company
Lapot Ltd

Count y of Origin
UK

Description of Artwork
Annua report

Dimensions
297 x 210 mm
113/4 x 81/4 in

TWO HUNDRED AND EIGHTY FIVE

DISAFFECTED YOUNG PEOPLE MOVED ON FROM FAIRBRIDGE INTO MAINSTREAM EDUCATION OR TRAINING.

237

MARGINALISED YOUNG PEOPLE GOT MORE INVOLVED IN THEIR LOCAL COMMUNITY THROUGH VOLUNTARY WORK

124

TRUANTS AND EXCLUDED PUPILS RETURNED TO SCHOOL

240

DEMOTIVATED YOUNG PEOPLE PROGRESSED FROM FAIRBRIDGE TO ANOTHER PERSONAL DEVELOPMENT ORGANISATION

279

YOUNG PEOPLE LEFT FAIRBRIDGE TO GO DIRECTLY INTO EMPLOYMENT

CHANGING ASPIRATIONS

Fairbridge is selective.

Self-starters are out: we want the demotivated to get involved. We want to engage those who are marginalised from society and difficult to reach. We want to inspire an enthusiasm for learning among those who are disenchanted with formal education and training. In short, we want to work with those most other organisations would rather leave behind.

It's a challenge.

That's why our biggest achievement this year is that we gave 2,510 young people a reason to get out of bed.

There are many organisations which exist to help young people find a job and many more which teach them technical skills and support them to acquire knowledge. There are precious few which offer them the first step: developing the desire to learn and the will to work.

Many organisations wanting to tackle social exclusion complain their biggest problem is engaging disaffected young people onto their programmes.

For these groups Fairbridge solves that problem; in effect acting as their outreach service, by supporting young people to aspire to achieve more in their lives — and, importantly, the belief that they are capable of doing so.

This year nearly 500 young people progressed from Fairbridge to other voluntary and youth organisations. We worked with other Alliance members, including Drive for Youth, The Duke of Edinburgh's Award, The Ocean Youth Trust, The Princes Trust, Raleigh International and The Weston Spirit to provide young people with roadways for continuous development.

For our young people it is a long and difficult journey to employment or returning to education. We recognise that, if we want to continue to demonstrate what works, we must create a means of measuring 'distance travelled', particularly in the development of personal and social skills.

This year we joined-up with 11 other organisations working with marginalised young people on a project to crack this problem.

Because we support young people for as long as they need us, many of the 2,040 who were new to Fairbridge this year are still with us. For others, all they needed was a chance to experience success and lift themselves out of a rut. Many of these were among the 11% who progressed from Fairbridge directly into employment or the similar number who moved onto formal education or training.

16

YOUNG PEOPLE CHANGED THEIR EATING HABITS

..AND DEVELOPING SKILLS

Fairbridge De Cymru's bushcraft project covers a wide range of skills from emergency first aid to household security, coping with loneliness to recycling furniture and cooking on a budget. Part of the success of the course has been bringing together other agencies such as the Samaritans and St John Ambulance.

All our courses develop personal and social skills, and this year we have expanded the range of projects developing life skills. These include the skills needed to make constructive use of leisure time, live independently and find and keep a job. These developments mean that there are many more opportunities for volunteers with appropriate skills, including employees from supporting companies, to make an active contribution to our work.

Proposals for all projects are submitted to the senior management team for approval. They follow a new national format to ensure that all aspects of development have been considered, from market testing the idea among young people to identifying the particular skills the project will deliver within the Fairbridge syllabus. As a result we have improved quality control and our ability to monitor what works.

Stages	How my business will do this
Concentration	Decide on set times to work on my business - trading and time developing my idea.
Perseverance	Trade for a few days per week, every week, stick with it and ride out the bad times.

YOUNG PEOPLE CHANGED THE WAY THEY MANAGE THEIR TIME

Many different organisations have been involved in supporting young people on our Sheafside MBA, Learn to Earn which is now up and running in Glasgow, Merseyside, London and Cardiff. We are particularly grateful to members of the business community, the people who have given up their time to talk to young people about how they have succeeded in their own ventures.

YOUNG PEOPLE CHANGED A HOBBY INTO A BUSINESS VENTURE

The idea for the Panorama project run by Fairbridge West was developed by a seasonal worker and a group of young people who were interested in developing their artistic skills. Young people produce, market and sell backdrops for nightclubs and themed parties.

12

More than 200 young people sailed on our 92' schooner Spirit this year. For many this was the first time they had travelled outside their county, they had lived and worked in close quarters with young people from other Fairbridge teams they hadn't met before. The separation from the problems they face in their everyday lives and the dramatic change of scene sparked a turning point for many young people.

The young people we work with are often characterised by an inability to make commitments and see things through but the year 1,674 of them completed a week-long Basic course with Fairbridge. 235 of them were supported by the ReStart Bursaries given by companies and trusts.

Young people from Fairbridge in Kent put aside their differences and worked together to write and produce their first CD. The performance project supported by the National Lottery Charities Board has been hugely popular with our client group. Next year it is expanding to include a sound engineering course and a business module which will involve young people in the hands-on running of a music agency.

When Bury and Rochdale probation service wanted to provide intensive personal and social skills training for young offenders they turned to Fairbridge in Greater Manchester for help. Staff from the two organisations worked together to develop the 3-6-3 programme which meets the attendance requirements of the National Standards for Supervision.

The Fairbridge security project in Newcastle deals directly with crime prevention as well as challenging the offending behaviour of young people. Young people work with this company which provides security on the surrounding estate. The Fairbridge centre OSU, which provides the funding and the Security Industries Training Organisation offers training leading to a formal qualification.

CHANGING BEHAVIOUR..

THE BUZZ CHANGED TO A NATURAL HIGH

DISCORD CHANGED TO HARMONY

PLANNING CHANGED THE OUTCOME

INSECURITY CHANGED INTO SECURITY

Everyone starts their involvement in Fairbridge with a week-long Basic course combining outdoor and group activities to give participants a sense of achievement.

There are never more than four young people to each member of staff on these courses, which means we have a good opportunity to assess young people's individual development needs.

After their Basic, participants can choose whatever courses motivate them. Our skill is in facilitating these activities by applying the development training principles of plan, do, review and apply) to ensure that participants develop new behaviours and attitudes which will help them overcome problems in their daily lives.

YOUNG PEOPLE CHANGED THEIR OUTLOOK ON LIFE

11

France sarl
société anonyme à responsabilité limitée

bientôt l'an 2000

muriel paris

Designers
Muriel Paris, Sophie Helmann

Art Director
Muriel Paris

Design Company
Atelier Muriel Paris and Alex Sinque

Country of Origin
France

Description of Artwork
Self-promotional postcards

Dimensions
150 x 105 mm
5⁷/₈ x 4¹/₈ in

trou de m

Vitrolles 1997 : le fascisme est passé

98 dit à 99 :

muriel paris et alex singer vous souhaitent une bonne année
20 rue dautancourt 75017 Paris • tél/fax : 01 46 27 35 61

dommage que
nous n'ayons
qu'une nuit pour
tout nous dire

muriel paris

**muriel paris & alex singer
self promotional postcards**
flat color used in the style of
agitprop posters provides a powerful
metaphor for communicating the
design confidence of the studio.
Aggressive, angular type and stark
color, supported by controversial
imagery, help make these designs
a memorable calling card.

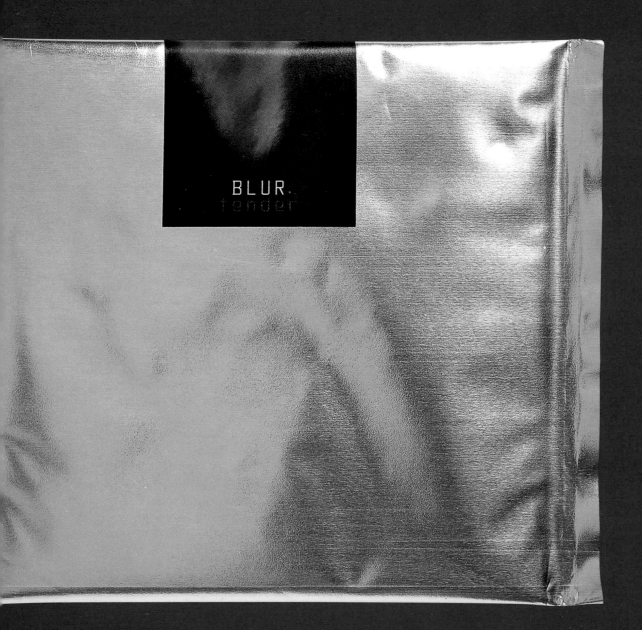

Designers
Richard Bull,
Chris Thomson

Art Directors
Richard Bull,
Chris Thomson

Illustrator
Graham Coxon

Design Company
Yacht Associates

Country of Origin
UK

Description of Artwork
CD single package

Dimensions
120 x 120 mm
4³/₄ x 4³/₄ in

blur - tender / straw

(above) the contrast between the metallic silver envelope and the printed paper band make this CD package visually and texturally intriguing. The cold of the metal is ironically set against the passionate, flame-like image and title of the work itself – "tender." Deliberately cryptic, the package is squarely aimed at a knowing audience.

(opposite) the strength of the logotype for the band Straw allows it to be interpreted in a number of different ways – absorbing the visual conventions of other logos – to chime with the title of each release. The singles are accompanied by enigmatic imagery presented in a consistent manner, which further builds the graphic identity of the band.

Designers
Richard Bull,
Chris Thomson

Art Directors
Richard Bull,
Chris Thomson

Photographer
Michael Oremerod (inside only)

Design Company
Yacht Associates

Country of Origin
UK

Description of Artwork
CD single package

Dimensions
120 x 120 mm
4³/₄ x 4³/₄ in

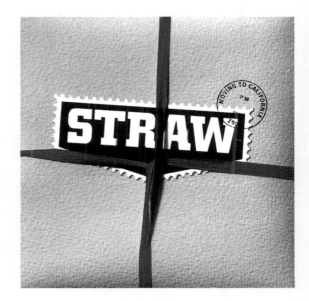

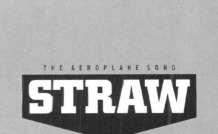

Designers
Roger Fawcett-Tang, Ben Tappenden, Mark Beach

Art Director
Roger Fawcett-Tang

Design Company
Struktur Design

Country of Origin
UK

Description of Artwork
Self-promotional brochure

Dimensions
165 x 214 mm
6¹/₂ x 8¹/₂ in

infrastruktur

the piece uses a cool, metallic cover to contain a varied and colorful portfolio of projects undertaken for clients. The information about the design company itself is held either on the cover or printed black on white on the first and last pages. By using a minimal approach to self-presentation, the company allows its portfolio to speak for itself.

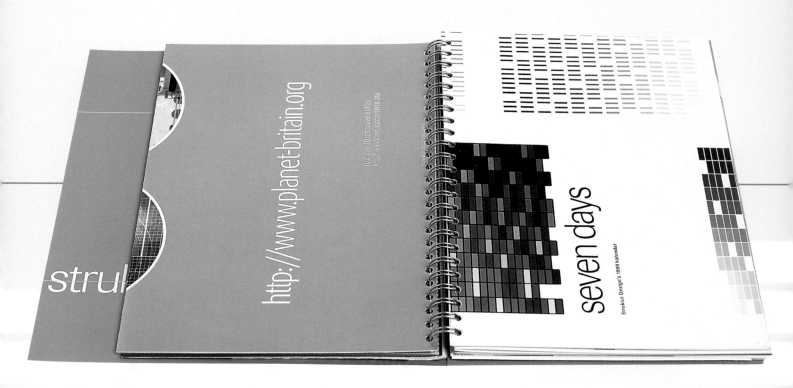

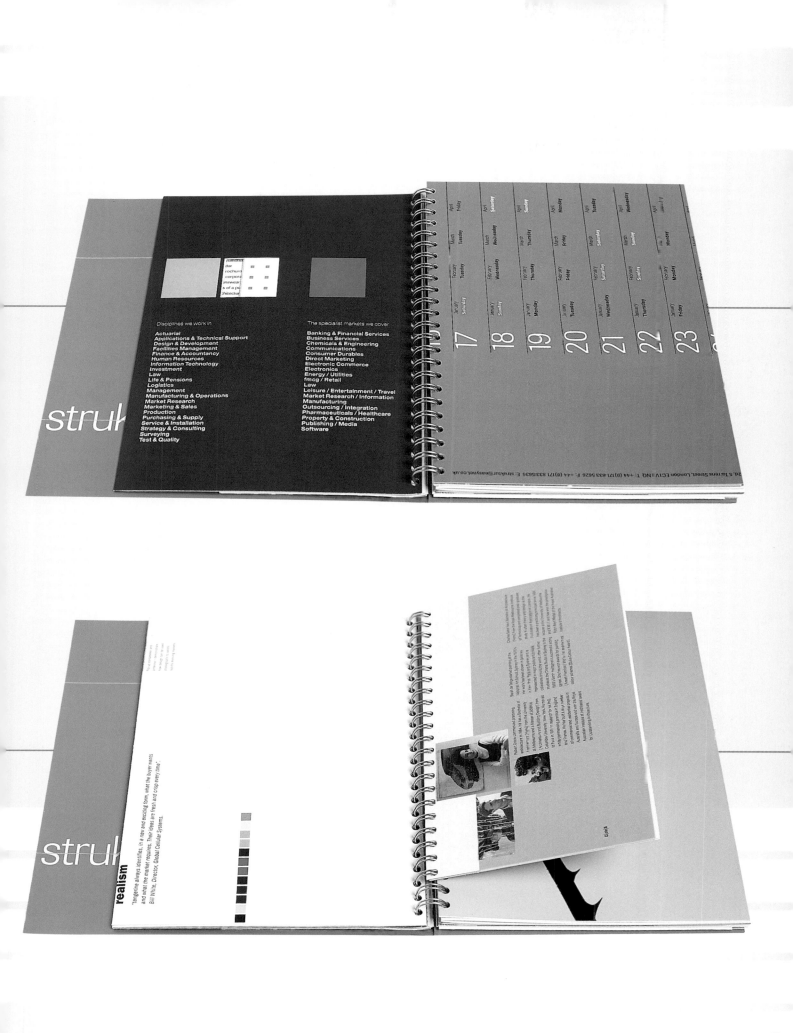

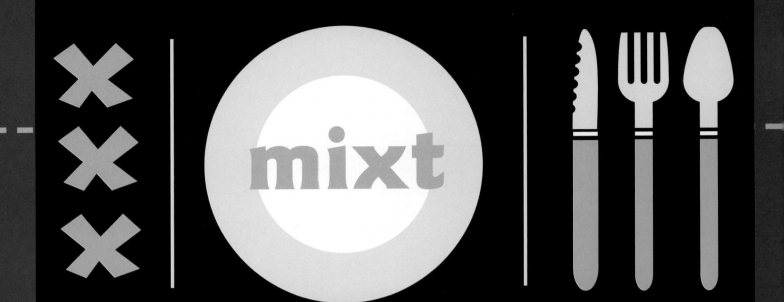

Spreek je Nederlands, of Engels ?

Doe c
en schrij

Designer
Taco Zuidema

Art Director
Taco Zuidema

Illustrators
8 font & Taco

Design Company
Taco Visual Communications in
co-operation with VBAT-Identities

Country of Origin
The Netherlands

Description of Artwork
Invitation to a multicultural
cooking festival

Dimensions
292 x 173 mm
11^1/$_2$ x 6^3/$_4$ in

AMsterd

Utrechtse Dw

1017 WH AMS

mixt

spurning conventional full-color photographic representations of food and cooking, the designer here uses a naive, flat color style in his invitation to an international festival of food. The checkerboard tablecloth design admits a range of color combinations, the most prominent of which draw attention to fragments of text — a witty approach to a well-worn subject.

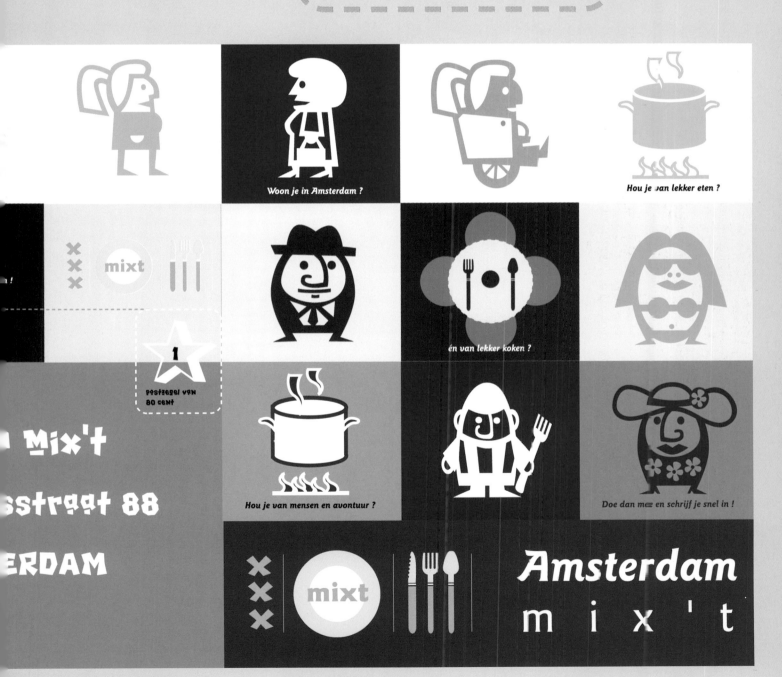

Woon je in Amsterdam ?

Hou je van lekker eten ?

én van lekker koken ?

Hou je van mensen en avontuur ?

Doe dan mee en schrijf je snel in !

On the turntables

Oh

SUPERNATU

…rvette..funkfeesten>>>>supervette..fu
supervette..funkfeesten>>>>

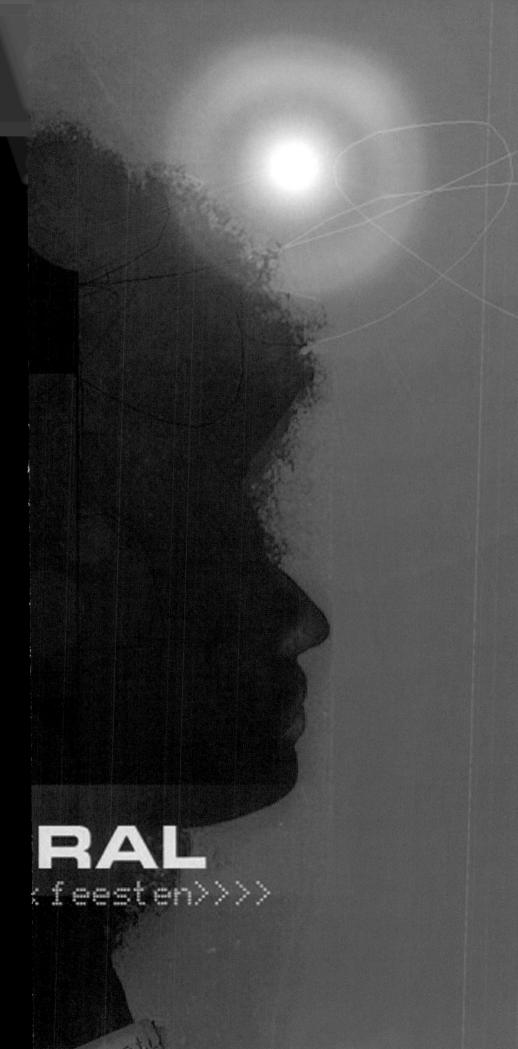

RAL
‹feesten›››

Designer
Taco Zuidema

Art Director
Taco Zuidema

Design Company
Taco Visual Communications

Country of Origin
The Netherlands

Description of Artwork
Supernatural "wallpaper" to
download from a web site

Dimensions
Scalable graphic

supernatural downloadable wallpaper
the silhouetted figure at the focus of this screensaver contains abstract
geometric patterns and rules picked out in shades of gray, demonstrating
how areas of flat color can be subtly exploited in ways that add interest. This,
combined with layered line graphics and type on a warm orange background,
creates an impression of depth and adds to a close, sultry mood.

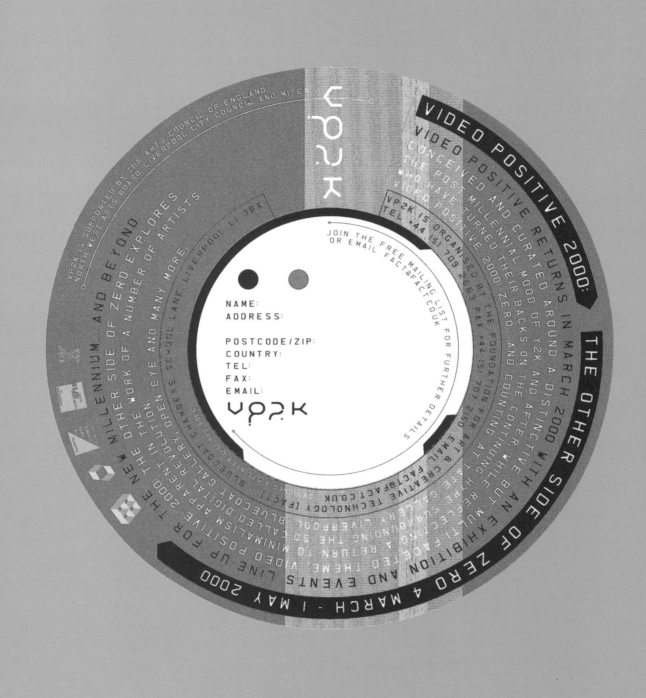

VIDEO POSITIVE 2000:

THE OTHER SIDE OF ZERO

VIDEO POSITIVE RETURNS IN MARCH 2000 WITH AN EXHIBITION AND EVENTS LINE UP FOR VIDEO POSITIVE 2000:

CONCEIVED AND CURATED AROUND A DISTINCTIVE BUT MULTI-FACETED THEME, VIDEO POSITIVE 2000: THE POST MILLENNIAL MOOD OF Y2K AND AFTER, A RETURN TO MINIMALISM THE OTHER SIDE OF ZERO EXPLORES

WHO HAVE TURNED THEIR BACKS ON THE CONTINUING APPEAL OF THE SO CALLED DIGITAL
VIDEO POSITIVE 2000: ZERO, AND COUNTING WHILE REFLECTING A SURROUNDING THE
NEW MILLENNIUM... AND BEYOND

VP2K IS ORGANISED BY THE FOUNDATION FOR ART AND CREATIVE TECHNOLOGY (FACT).

VP2K IS SUPPORTED BY THE ARTS COUNCIL OF ENGLAND, NORTH WEST ARTS BOARD, LIVERPOOL CITY COUNCIL, AND MITES

NAME:
ADDRESS:

POSTCODE/ZIP:
COUNTRY:
TEL:
FAX:
EMAIL:

JOIN THE FREE MAILING LIST FOR FURTHER DETAILS
OR EMAIL FACT@FACT.CO.UK

TEL +44 151 709 2663 FAX +44 151 707 2150 EMAIL FACT@FACT.CO.UK

THE WORK OF A NUMBER OF ARTISTS
INTUITION EYE AND MANY MORE.
REVOLVE/OPEN EYE AND MANY MORE.
APPAREY/OPEN EYE AND MANY MORE,
CHAMBERS, SCHOOL LANE, LIVERPOOL L1 3BX
BLUECOAT DIGITAL GALLERY, LIVERPOOL
Video a Splinter (8)151 709 9086

4 MARCH - 1 MAY 2000

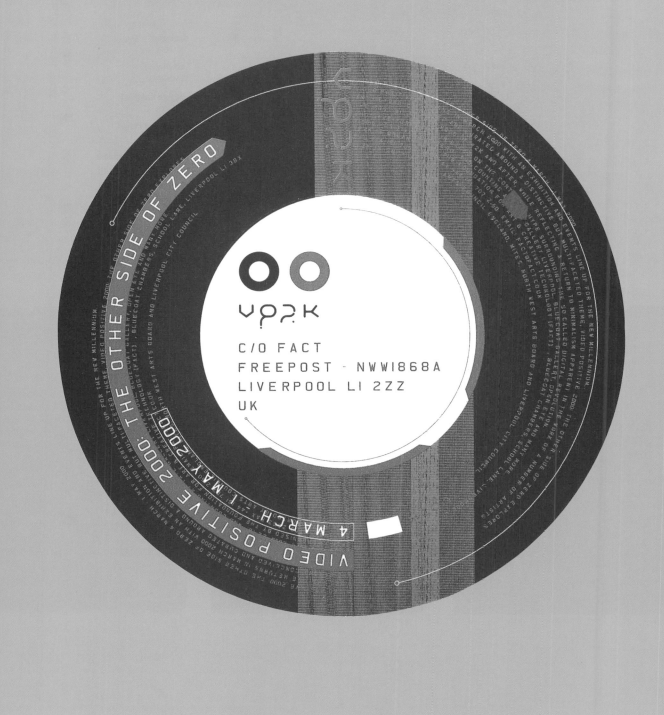

video positive 2000

echoing the shape and texture of a 7 in vinyl record, these exhibition flyers are printed in two fluorescent inks. Their brightness is instantly arresting, and the circular arrangement of type challenges the observer to decipher the information. Despite the adventurous approach, the designer has still succeeded in accommodating the logos of five different sponsors.

Designer
David Hard

Art Director
Sam Wiehl

Design Company
Splinter

Country of Origin
UK

Description of Artwork
Circular flyer for a festival of video and digital media

Dimensions
170 x 170 mm
6²/₃ x 6²/₃ in

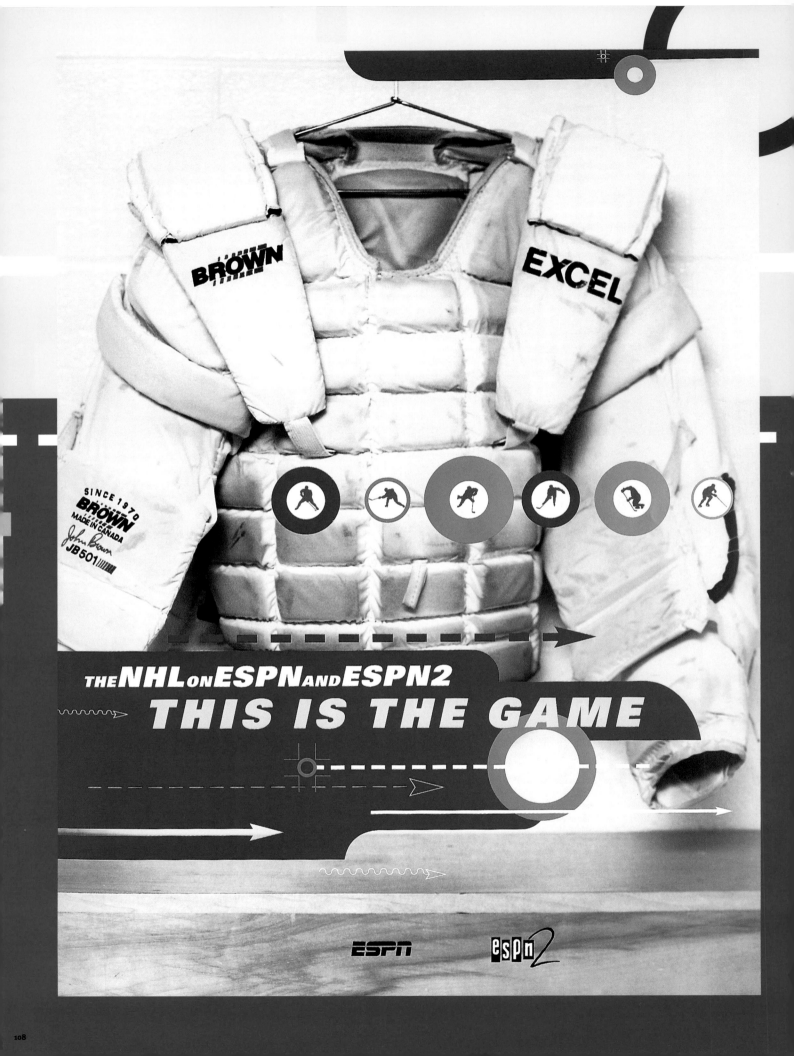

Designers
David Slatoff, Tamar Cohen,
David Jacobson, Kathryn Hammill

Photographer
Graham McIndoe

Art Direction
David Slatoff, Tamar Cohen

Design Company
Slatoff + Cohen Partners Inc.

Country of Origin
USA

Description of Artwork
Marketing kit for the National Hockey
League (NHL) on the cable television
networks, ESPN and ESPN2

Dimensions
Various

the nhl on espn and espn2

color, imagery, and type unite the appearance of the
poster (left) and the banner (below), both of which
promote television broadcasts of ice hockey. The
bright, flat color is particularly well suited to the
silk-screened banner, while the poster can hold a full-
color photographic image. Geometric imagery and
directional arrows reversed out of the strong blue
panel create dynamism and set up a clear graphic
identity that can be applied across different media.

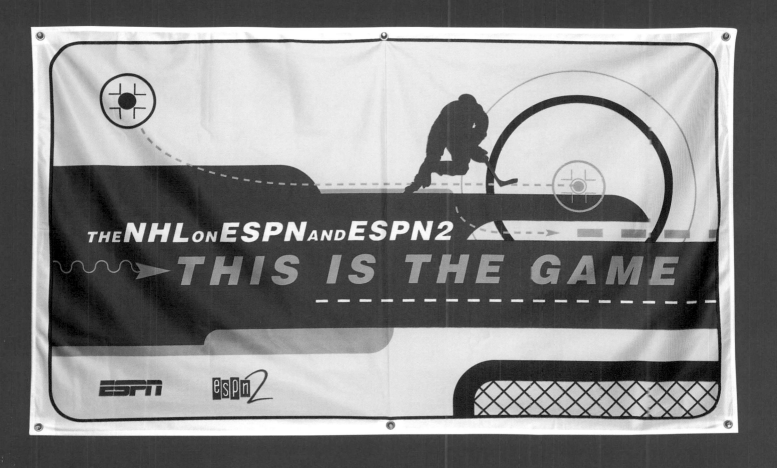

Designer
Red Design

Art Director
Red Design

Photographers
Tom Carley,
Deirdre O'Callaghan,
Bruce Havy

Design Company
Red Design

Country of Origin
UK

Description of Artwork
Digipack CD

Dimensions
140 x 125 mm
5¹/₂ x 4⁷/₈ in

tim hutton

the full-color abstracted travel imagery on the cover of this CD is drawn together by the use of strong yellow, which then appears as the exclusive color on the inside of the package, and on the CD itself. The purity of the intense lemon color within cuts through the muddy hues of the outer cover.

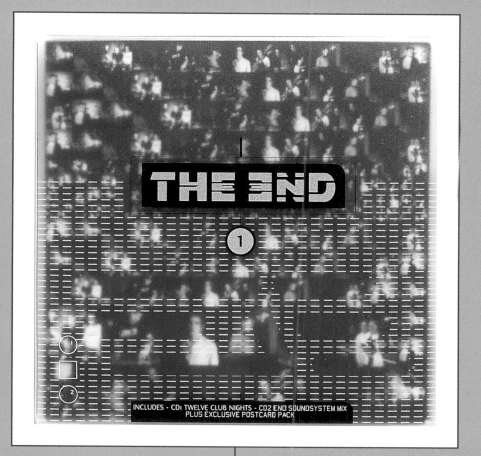

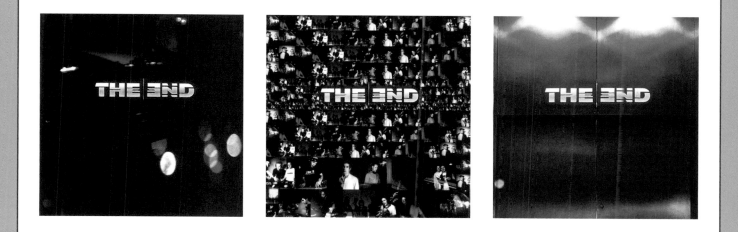

the end

consistent placement of an unvarying logotype gives
this set of CDs a clear identity. Deeply colored
background images have bright highlights that mirror
the sheen of the logo, and the absence of a textual title
transfers the function of identifying the product
to the images themselves.

Designer
Red Design

Art Director
Red Design

Photographers
jamie B, Dom@Drunk,
Paul H, Julian Barton,
Deirdre O'Callaghan,
Bruce Havy

Design Company
Red Design

Country of Origin
UK

Description of Artwork
Polypropylene pack
containing two CDs
and 13 postcards

Dimensions
130 x 130 mm
5 1/8 X 5 1/8 in

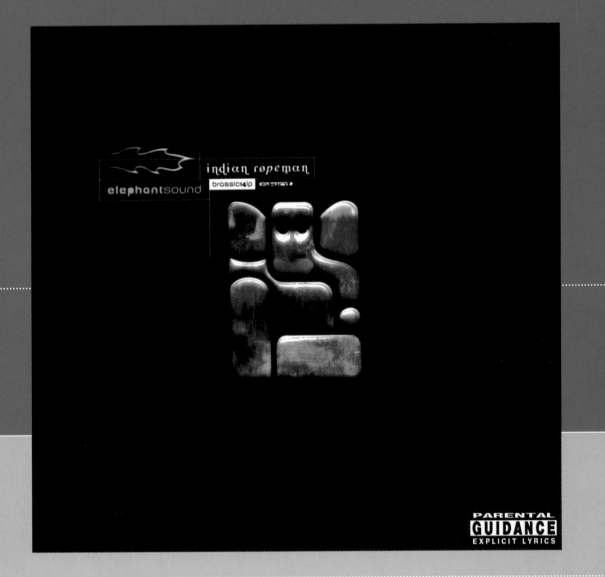

Designer
Red Design

Art Director
Red Design

Photographer
Leigh Pearce

Design Company
Red Design

Country of Origin
UK

Description of Artwork
12 in album sleeve and
two inner bags

Dimensions
305 x 305 mm
12 x 12 in

elephant sound - indian ropeman
this 12 in record sleeve contains two further printed
sleeves. The outer sleeve, with its four-color image of
sculptural metalwork and a flame motif provides the
elemental blue, ocher, and black tones, which are
developed within. Here, elements anchored to a formal
grid-based layout are mixed with apparently haphazard
brushstrokes and paint effects. All text is white, reversed
out of the background, except for the letters that identify
tracks on the four sides of vinyl. These are picked out in
shades of the prevailing second color.

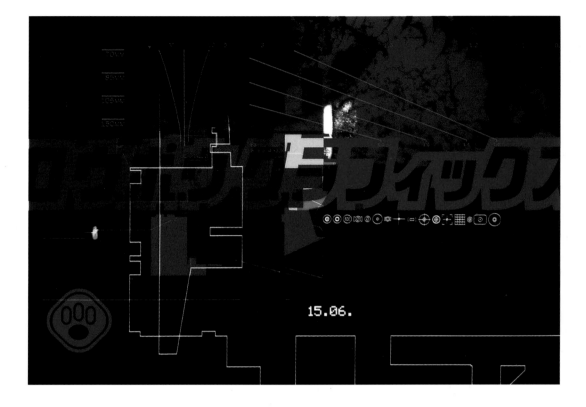

d-fuse screen graphics

designed to be projected onto the walls of a
nightclub, these intensely colored images
exploit the richness of hue that be only achieved
by transmitted, rather than reflected, light. The
effect is enhanced by the placement of luminous
quasi-scientific imagery – the fine lines of plans
and blueprints – against a black background.

Designer
Michael Faulkner

Art Director
Michael Faulkner

Design Company
Raw Paw Graphics

Country of Origin
UK

Description of Artwork
35 mm slides for a
nightclub installation

Dimensions
35 mm transparency

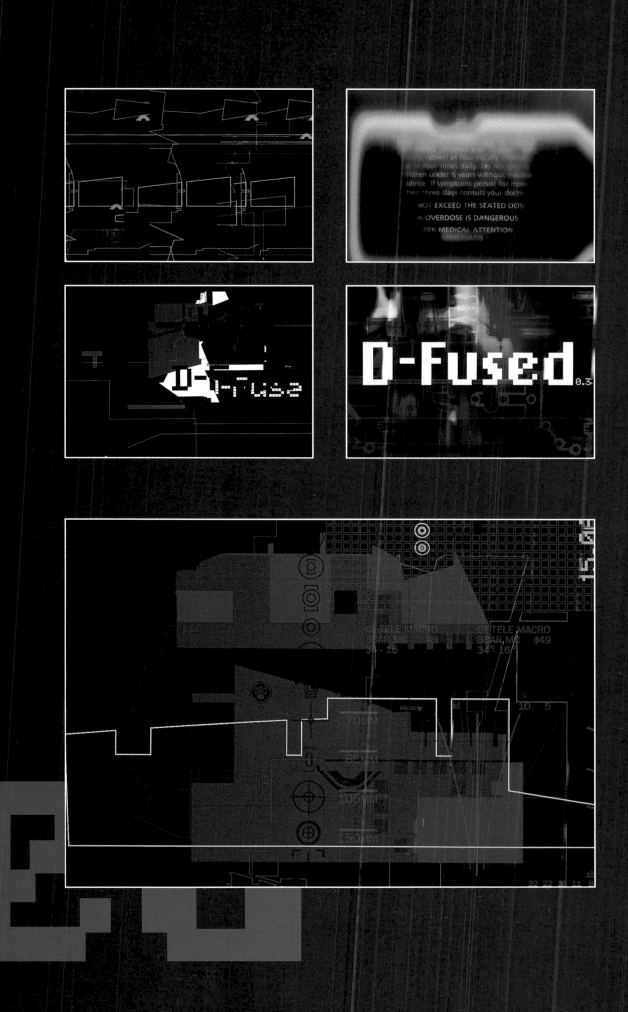

227 gallery catalog

the monochrome cover of this catalog (left) is created by printing in black ink on the reverse of thin, translucent paper. Text within is printed on the right hand page only, ghosting through in reverse on the following left hand page, thus creating an impression of precious ephemerality. When the works of art are presented, the stock changes to a thick matt art paper, and the structure of each page is determined by the square shape of the images. The portfolio is introduced and concluded by solid blocks of strong color (right), which presage the format of the pieces. The works are mirrored on the right hand pages by an equivalent area of white space enclosed by a fine gray rule (below right) – this contains the name of the artist and date of the installation. The white area has the effect of focusing attention on the image opposite.

Designer
Peter Bilak

Photographer
Frank van Helfteren

Design Company
Peter Bilak

Country of Origin
The Netherlands

Description of Artwork
Presentation book for
self-initiated gallery space

Dimensions
148 x 210 mm
5 7/8 x 8 1/4 in

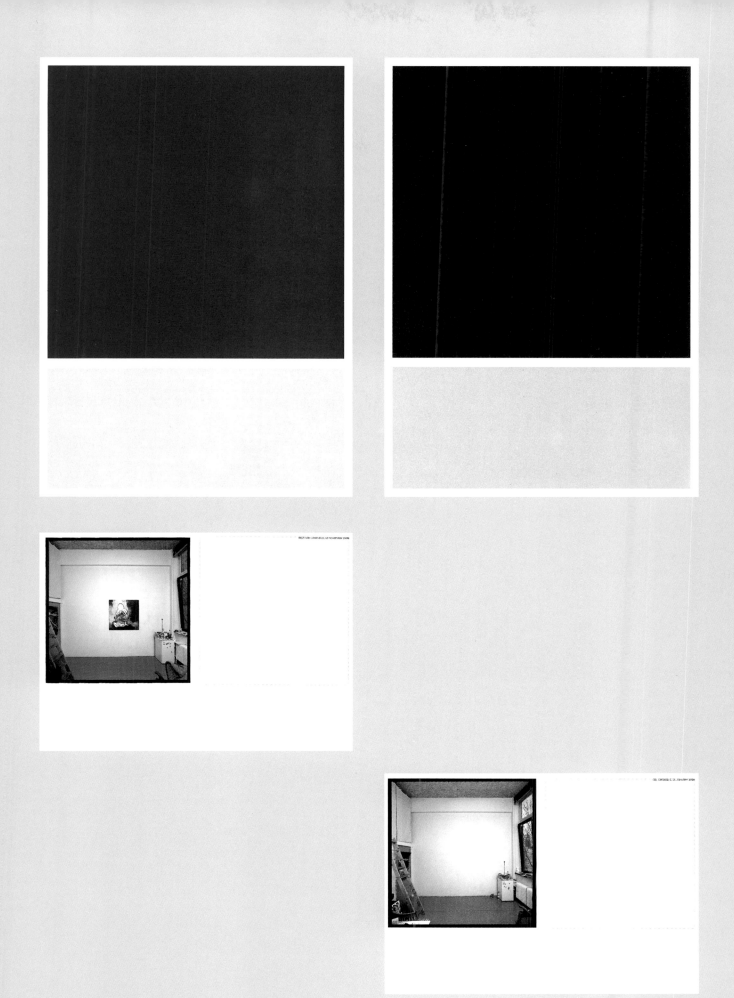

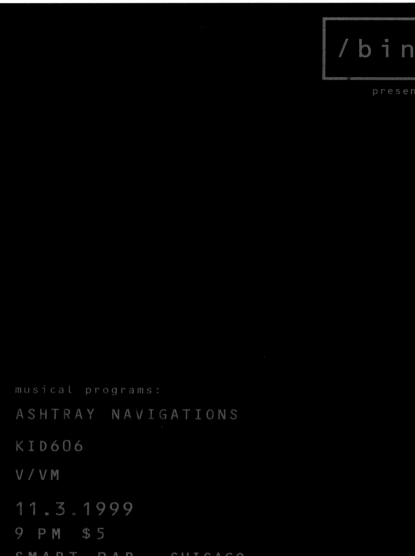

musical programs:

ASHTRAY NAVIGATIONS

KID606

V/VM

11.3.1999

9 PM $5

SMART BAR - CHICAGO
3730 n. clark (773.549.4140)
egoiste@enteract.com for info
www.enteract.com/~egoiste

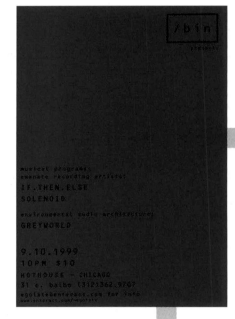

/bin series

stark minimalism is used here to create a distinctive identity for a series of handbills promoting musical events. Consistent but simple use of typeface and layout allows the concept to be quickly extended to new events by changing the paper stock and ink color schemes only.

Designer
Bob Davies

Art Directors
Mike Javor, Bob Davies

Design Company
Robert C Davies Jr

Country of Origin
USA

Description of Artwork
Postcards announcing performances featuring a global selection of experimental electronic music

Dimensions
108 x 152 mm
4¹/₄ x 6 in

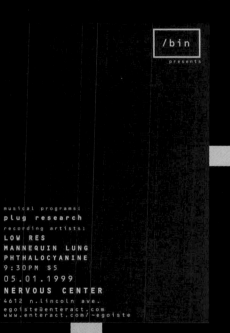

/ b i n

presents

musical programs:
endpoint recording artists:

.diminish

NUDGE

SALVO BETA

SUPPLEMENT

12.18.1999

9 PM $10

HOTHOUSE – CHICAGO

31 e. balbo (312)362.9707

egoiste@enteract.com for info
www.enteract.com/~egoiste

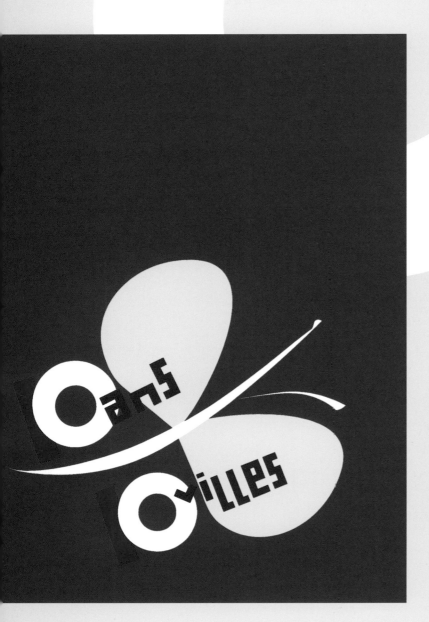

10 ans, 10 villes: festival d'affiches de chaumont
this card (left) advertising a poster festival employs the strong graphic symbolism of a butterfly and heralds a strong three-color identity for the exhibition. The boldness of the approach allows related publications (right) to pick up one, two, or all of the colors, extending the identity economically across a range of printed materials.

Designers
Muriel Paris, Alex Sinque

Art Directors
Muriel Paris, Alex Sinque

Illustrators
Muriel Paris, Alex Sinque

Design Company
Atelier Muriel Paris and Alex Sinque

Country of Origin
France

Description of Artwork
Card and brochure advertising a
poster festival

Dimensions
Various

field of dreams invitation

this booklet announces a design competition sponsored by a paper manufacturer. The quotation "you can observe a lot by watching" was worked into a poster design; the poster was then cut and bound as a small-format booklet. The jarring effect of converting one medium into another is accentuated by the emphatic use of black on one printed side and red on the reverse. By using a coarsely screened image and fragmented type, the work forces the viewer to think about the nature of print.

Designer
John Bielenberg

Photographer
John Bielenberg

Design Company
Bielenberg Design

Country of Origin
USA

Description of Artwork
Booklet announcing a design
competition

Dimensions
103 x 140 mm
4 x 5½ in

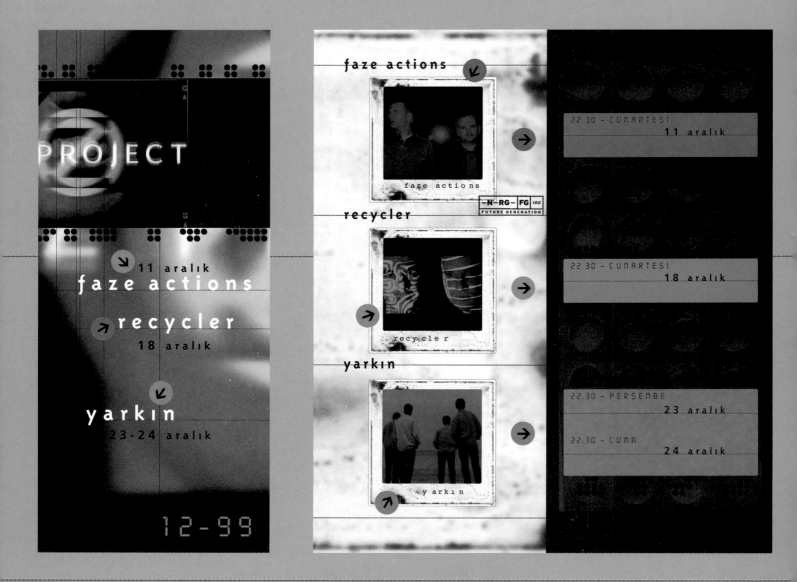

oz project

the visual identity of this night club is based around a brown and blue logo. The colors used in the stationery create a corporate tonal range that is applied to and extended in the flyer, which adds a tonally similar green. The three colors identify events at the club and, used in duotones, they create an uncertain, nocturnal mood.

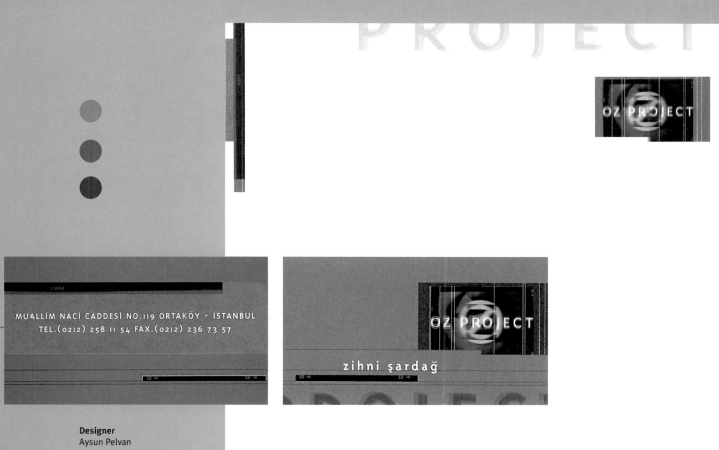

MUALLİM NACİ CADDESİ NO.119 ORTAKÖY - İSTANBUL
TEL.(0212) 258 11 54 FAX.(0212) 236 73 57

zihni şardağ

Designer
Aysun Pelvan

Art Director
Gulizar Cepoglu

Illustrator
Aysun Pelvan

Photographer
Niels Stoltenborg

Design Company
Gulizar Cepoglu Design Co.

Country of Origin
Turkey

Description of Artwork
Flyer, stationery and card for
a night club

Dimensions
Various

MUALLİM NACİ CADDESİ NO.119 ORTAKÖY - İSTANBUL TEL.(0212) 258 11 54 FAX.(0:12) 236 73 57

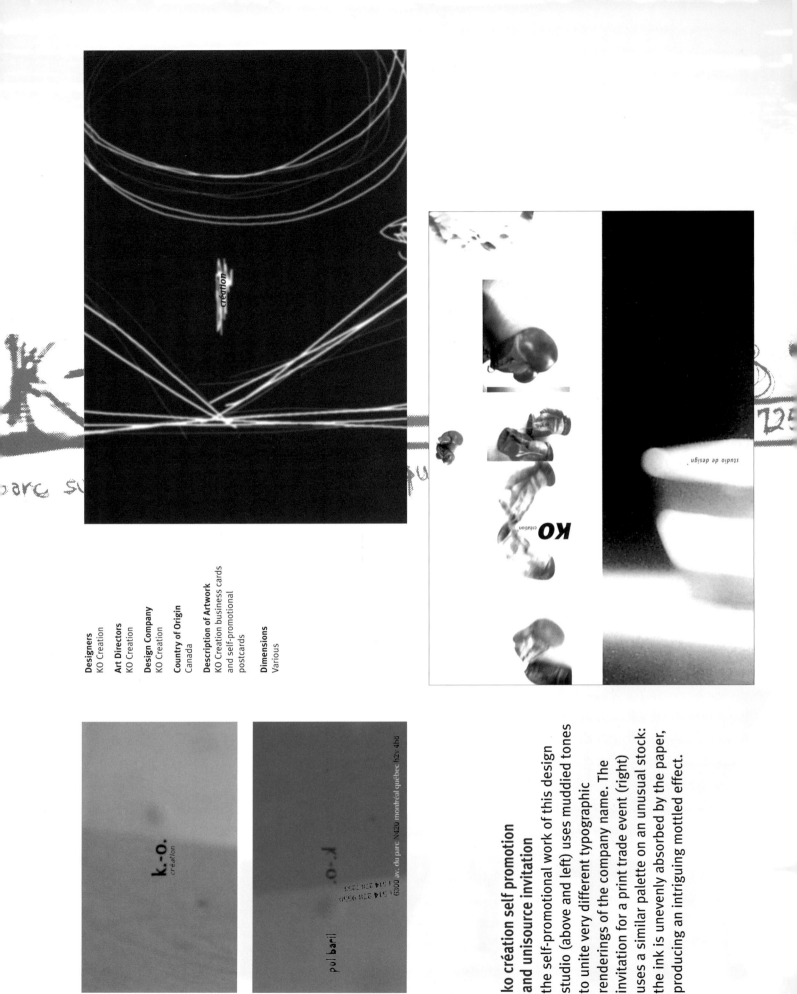

Designers
KO Creation

Art Directors
KO Creation

Design Company
KO Creation

Country of Origin
Canada

Description of Artwork
KO Creation business cards and self-promotional postcards

Dimensions
Various

ko création self promotion and unisource invitation

the self-promotional work of this design studio (above and left) uses muddied tones to unite very different typographic renderings of the company name. The invitation for a print trade event (right) uses a similar palette on an unusual stock: the ink is unevenly absorbed by the paper, producing an intriguing mottled effect.

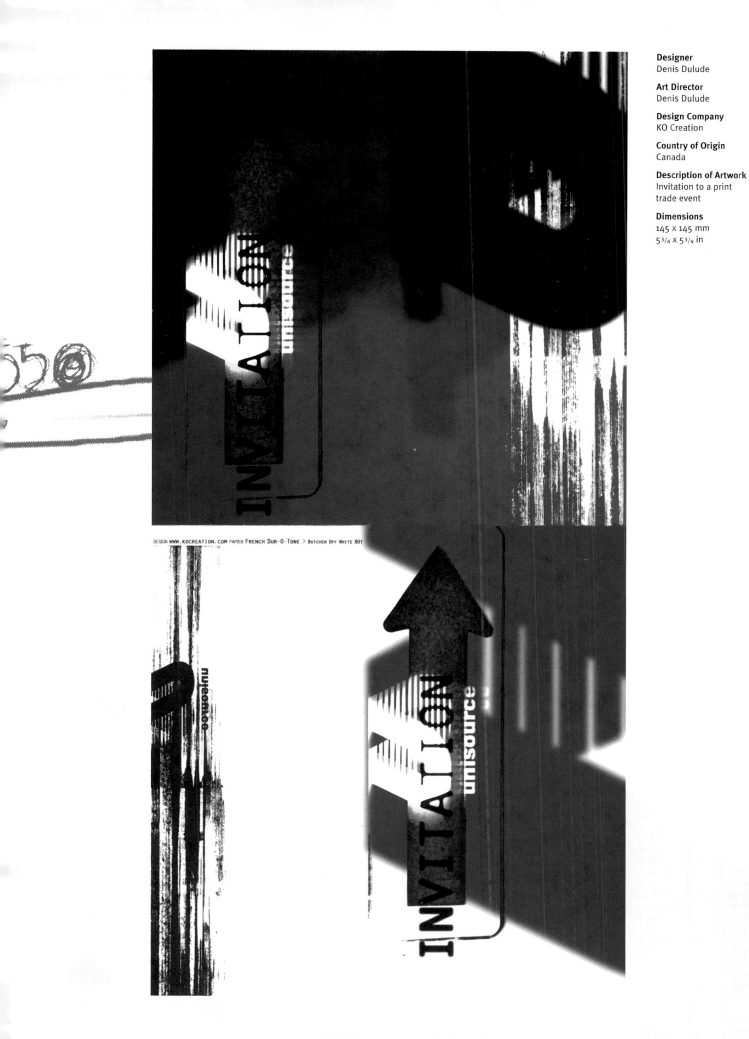

Designer
Denis Dulude

Art Director
Denis Dulude

Design Company
KO Creation

Country of Origin
Canada

Description of Artwork
Invitation to a print
trade event

Dimensions
145 x 145 mm
5³/₄ x 5³/₄ in

DESIGN WWW.KOCREATION.COM PAPIER FRENCH DUR-O-TONE > BUTCHER OFF WHITE 80T

Designer
Lluis Jubert

Art Director
Ramon Enrich

Illustrator
Ramon Enrich

Design Company
Espai Grafic

Country of Origin
Spain

Description of Artwork
Poster and brochure for art exhibition

Dimensions
188 x 220 mm
7²/₅ x 8²/₃ in

Kunst kaufen? Wir machen's möglich!

vom 19. November 1999 bis 9. Januar 2000

Kunst

supermarkt

1. Frankfurter Kunst-Supermarkt
2. Marburger Kunst-Supermarkt

99

kunst supermarkt

areas of strong, flat color and naive illustration are used
here to promote art consumerism in an exuberant and
unthreatening manner. The ease of buying art at this
exhibition is likened to supermarket shopping on the
poster (above) and the artworks are presented without
customary reverence within the brochure (left). The
clever logo relies upon isolating the word "art" from
"supermarkt" by the simple use of two colors.

Bill Stephenson sp‥
residence at the Childr‥
during that time, only a‥
book, are courageous, s‥
midst of a busy hospita‥

I would like to express‥
and parents who have l‥

children's hospital project

this book is cleverly printed in just two colors to create subtle differences in the tone of both text and images, as in the title on the cover (right). On the pages within, the purely typographic spreads use bright 100 percent orange and blue, contrasting with softer tints on the pages where the images appear. The designer contributes to the mood of the images with color: the cover image (a blue and orange duotone) is warmer than the more dispassionate (blue only) images within.

Designer
Dom Raban

Photographer
Bill Stephenson

Design Company
Eg.G

Country of Origin
UK

Description of Artwork
36-page book documenting the work of Bill Stephenson, photographer in residence at Sheffield Children's Hospital

Dimensions
210 x 148 mm
8¼ x 5⅞ in

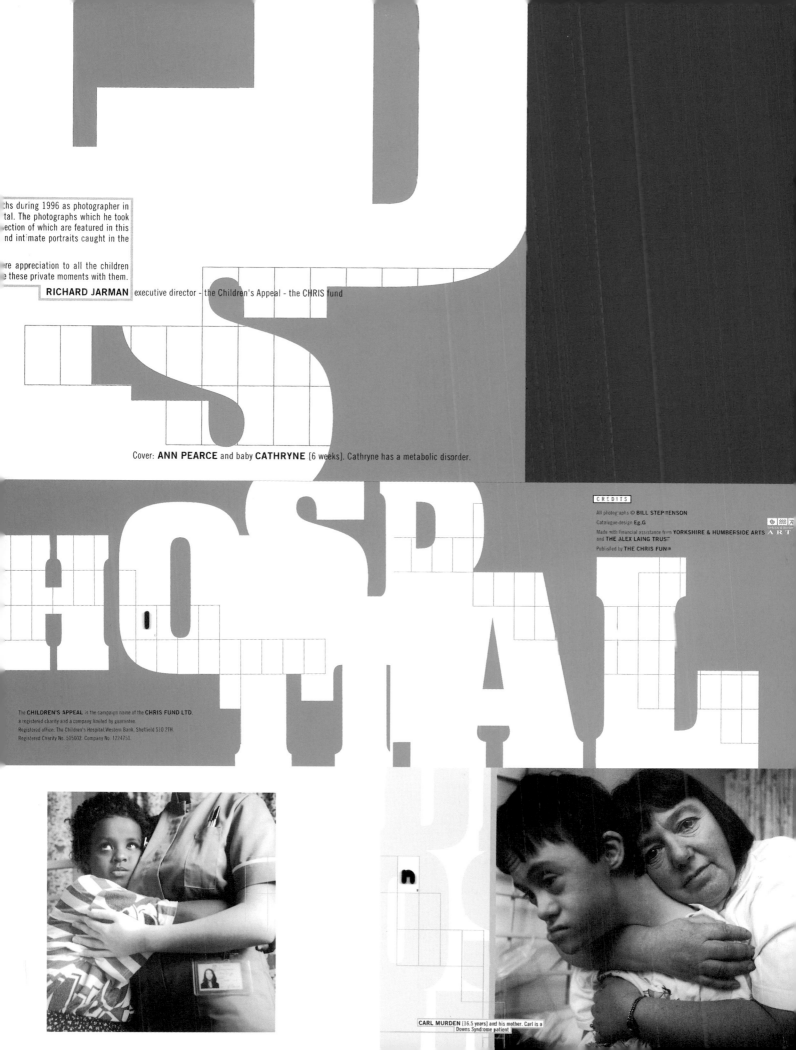

...hs during 1996 as photographer in ...tal. The photographs which he took ...ection of which are featured in this ...nd intimate portraits caught in the

...re appreciation to all the children ...e these private moments with them.

RICHARD JARMAN executive director - the Children's Appeal - the CHRIS fund

Cover: **ANN PEARCE** and baby **CATHRYNE** [6 weeks]. Cathryne has a metabolic disorder.

CREDITS

All photographs © BILL STEPHENSON
Catalogue-design Eg.G
Made with financial assistance from YORKSHIRE & HUMBERSIDE ARTS
and THE ALEX LAING TRUST
Published by THE CHRIS FUND

CARL MURDEN [16.5 years] and his mother. Carl is a Downs Syndrome patient

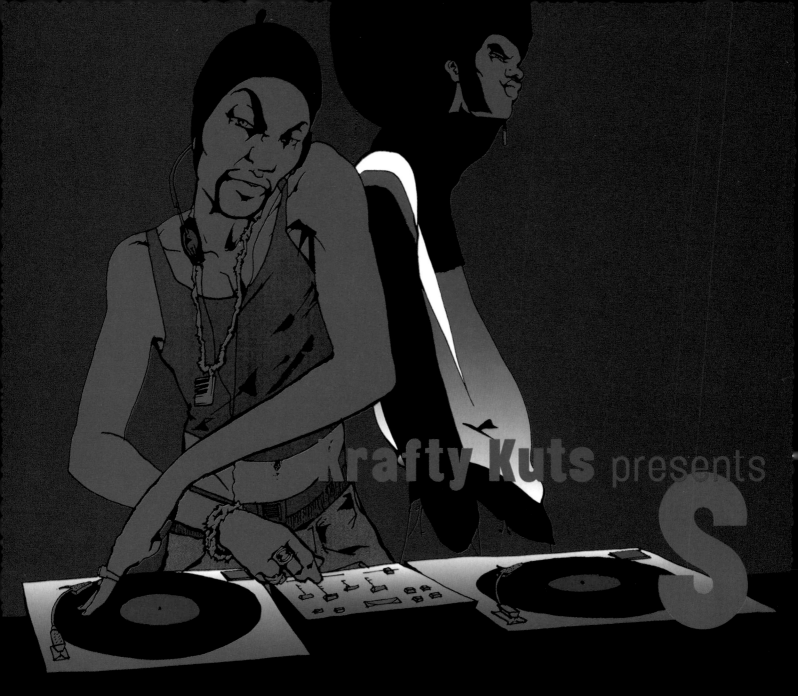

Krafty Kuts presents

S

Lacerba Records proudly presents **the** breakbeat behemoth, a mammoth meltdown of Old Skool Hip Hop, Nu Skool Breaks and fierce Funk featuring **Fatboy Slim**, **Mixmaster Mike**, **Jurassic 5**, **Pepe Deluxe**, **Quincy Jones**, **Freddy Fresh** and De La Soul

Slam it, damn it!

slam the breaks on

comic-book styling conveys brash energy on this CD
cover, and the strong coloring and harsh shadows
suggest a club atmosphere. Irregular letter spacing of
the sans serif face is a homage to jazz record covers
from the 1950s and 1960s and conveys a dynamism
directly related to the title of the CD.

Designer
Mark Edwards

Art Directors
Mark Edwards, Roger Quail

Illustrator
Kristian Russel

Design Company
Designed

Country of Origin
UK

Description of Artwork
CD and album packaging

Dimensions
305 x 305 mm
12 x 12 in

4 Safety and Security

Safety: DLR Ltd is directly responsible for strategic safety matters relating to the railway. The DLR Safety Case was transferred to DRML, the franchisee, in 1997. DLR Ltd monitors the franchisee's safety performance on a regular basis. The Safety Case has been modified to take account of the Lewisham Extension project and DLR Ltd will also be monitoring the safety performance of CGL Rail, the concessionaire.

During 1998/99, DLR Ltd continued to discharge its responsibilities through its established safety management processes. DRML reports on a monthly basis, through the Franchise Agreement, on its safety performance, which is reviewed by DLR Ltd and discussed at regular safety meetings with the franchisee. On an annual basis, DLR Ltd contracts with an external auditor to provide an independent review of DRML's performance in meeting the requirements of its Safety Management System, the recommendations from which are reported and monitored at the safety meetings. DLR Ltd will be monitoring the safety management regime of the Lewisham concessionaire in a similar way. All these matters are reviewed regularly by the DLR Ltd Board, advised by the Board member with special interest in safety.

Security: The DLR provides a high level of security for its passengers and staff through the use of closed circuit television on stations, passenger service agents on all trains, and a dedicated unit of the British Transport Police based at the railway's Poplar headquarters. The same level of security has been extended to the new Lewisham Extension.

An independent review of DLR's passenger safety and security system was undertaken in 1998 and has been followed up by regular review meetings between the police and the franchisee. Improvements in hand include a review of station lighting to ensure consistent standards and extending and improving the quality of CCTV coverage at stations. There has also been a close working relationship between DLR Ltd and local authorities to increase security and assist regeneration is areas around some stations.

DLR Ltd, in conjunction with DRML, is to seek accreditation for DLR stations under a Secure Stations Scheme set up by the Department of Environment, Transport and the Regions. The aim of the scheme is to reduce crime and the public's fear of crime.

3 Service Levels The major change to services between April 1998 - March 1999 was the closure of Mudchute and Island Gardens stations in January 1999 to enable essential works on the new extension to Lewisham. A free replacement bus service - in DLR livery including a low-floored, fully accessible vehicle - was introduced to minimise passenger inconvenience.

Off-peak services on weekdays between Beckton and Tower Gateway were improved to coincide with the LT bus link between DLR's Prince Regent station and London City Airport and through tickets were introduced. A further improvement - to a 10-minute frequency - was introduced to coincide with the opening of the Lewisham Extension.

Service levels for the Lewisham Link will have trains eventually operating at 4-minute levels during the peak, and at 8- minute or 12- minute intervals at off-peak times and at weekends. Services will be provided between Lewisham and Bank and Lewisham and Stratford. Additional services to other destinations, including Tower Gateway and the Royal Docks, will be considered during 1999/2000.

DLR Ltd expects a significant number of people to use DLR services to reach the Millennium Dome via its new stations at Greenwich and Cutty Sark for Maritime Greenwich. There will be direct and frequent links to the Dome via the Millennium Transit bus service and by river shuttle services from Greenwich Pier.

Service plans in the future will be influenced significantly by further developments in the Docklands area.

Designer
Mark Edwards

Art Director
Mark Edwards

Photographer
Nick Daly

Design Company
Designed

Country of Origin
UK

Description of Artwork
Annual report for DLR Limited 1998/1999

Dimensions
210 x 297 mm
8¼ x 11¾ in

dlr annual report 1998/1999

here, oversaturated photographic images add interest to a workaday subject, and the prevalence of blue, with flashes of red, resonates with the corporate colors of the rail operator. The angular compositions are set against large areas of flat color and combined with bright type, adding still more drama.

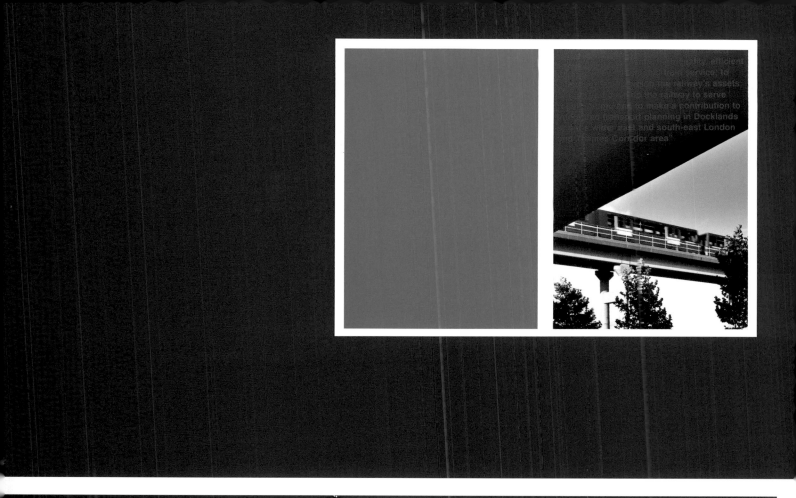

"...ly efficient ... train service; to ... on the railway's assets; ... the railway to serve ... to make a contribution to ... transport planning in Docklands ... the wider east and south-east London ... Thames Corridor area"

"We all share a vision of what this great little railway can do for London, and we will work hard to deliver it"

Carte de réservation

és .

Ch / D.

À renvoyer dûment complétée, soit par courrier à Charleroi/Danses, rue du Fort 45 - 6000 Charleroi, soit par fax au 071/20 56 49.

Saison 98.99

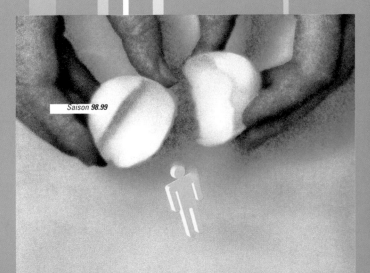

Saison 98.99

Charleroi / Danses

Musiques:

24 oct . 20h00 . Les Tanneurs . Bruxelles

Huelgas Ensemble, Paul Van Nevel
Beatriz da Conceição & António Rocha

Paul Van Nevel et l'Ensemble Huelgas explorent cette mélancolie de l'âme que l'on retrouve dans toute la musique portugaise depuis les temps les plus reculés. Beatriz da Conceição et António Rocha, deux *"fadistas"* contemporains se sont joints à l'aventure et dès les premières notes, la magie opère: on ressent la *"saudade"* cette mélancolie qu'éprouve celui qui aspire désespérément au bonheur amoureux...

| 900 / 675FB | P: | 450FB | FADO | PORTUGAL | UNE PRODUCTION DE LA SOCIÉTÉ PHILHARMONIQUE DE BRUXELLES. PRÉSENTÉE AVEC LE PLAN K |

31 oct . 20h00 . Les Tanneurs . Bruxelles

Ensemble Al Kindi
Sabri Moudallal & Omar Sarmini

L'école de chant classique du monde arabe oriental présentée par son maître incontesté Sabri Moudallal, ainsi que par Omar Sarmini, interprète infiniment sensible de la jeune génération. L'ensemble Al Kindi nous restitue l'atmosphère intimiste et riche en émotions du *"salon de musique arabe"*, tel qu'il existait au 19e siècle, avec ses divans, ses tapis, et ses narguilés...mais surtout ses époustouflantes improvisations et joutes ludiques ponctuées de soli instrumentaux à la flûte, au luth et aux percussions.

| 750 / 565FB | P: | 375FB | CHANT | SYRIE | UNE PRODUCTION DE LA SOCIÉTÉ PHILHARMONIQUE DE BRUXELLES / EN PLAN K |

14 nov . 20h00 . Les Tanneurs . Bruxelles

Tim Berne trio "Paraphrase"

Tim Berne - saxophone, Drew Gress - basse, Tom Rainey - batterie

"Comme un prolongement abstrait de la musique funk", le travail de recherche d'un *"son de groupe"* a poussé ce prodigieux saxophoniste aux confins de l'improvisation, vers une expression à la fois brute, sauvage et subtile... toujours très prenante.

| 750 / 565FB | P: | 375FB | JAZZ | USA | UNE PRODUCTION DE LA SOCIÉTÉ PHILHARMONIQUE DE BRUXELLES À PLAN K . EN COLLABORATION AVEC L'AUT/TRONOUT / DANS LE CADRE DE L' AUDI JAZZ-FESTIVAL |

28 avr . 20h00 . Les Tanneurs . Bruxelles

L. Blondiau, N. Thys, M. Seba, J.P. Catoul, E. Vann,
P. Abraham, F. Simtaine, P. Zurstrassen, P. Radoni

"Jeunes Lions et Vieux Tigres du Jazz belge"

Neuf musiciens belges réunis dans un programme à géométrie variable où standards revisités alternent avec compositions originales. Héritages du passé, ruptures/continuité, souplesse et affinités pour une rencontre exceptionnelle à travers trois générations qui n'ont jamais été présentées sous la forme d'un groupe.

| 600 / 450FB | P: | 300FB | JAZZ | BELGIQUE | EN COPRODUCTION AVEC LA SOCIÉTÉ PHILHARMONIQUE DE BRUXELLES . EN COLLABORATION AVEC LES TANNEURS |

3 mai . 20h00 . Les Tanneurs . Bruxelles

Philip Glass

Inclassable et parfois controversé, Philip Glass nous présente un ensemble de nouvelles compositions pour piano solo: une belle rencontre intime au sommet!

| cat 1: 1200 / 900FB | P: | 600FB | cat 2: 800 / 600FB | P: | 400FB | PIANO | USA | EN COPRODUCTION AVEC LA SOCIÉTÉ PHILHARMONIQUE DE BRUXELLES . EN COLLABORATION AVEC LES TANNEURS |

15 mai . 20h00 . Les Tanneurs . Bruxelles

Jafar Husain Khan & ensemble

La beauté envoûtante des chants Qawwali d'Inde du Nord, par l'un des grands maîtres encore méconnu en Europe.

| 750 / 565FB | P: | 375FB | CHANT | INDE DU NORD | EN COPRODUCTION AVEC LA SOCIÉTÉ PHILHARMONIQUE DE BRUXELLES . EN COLLABORATION AVEC LES TANNEURS |

Une collaboration entre Charleroi/Danses et la Société Philharmonique de Bruxelles.

Une programmation inscrite dans le cadre des cycles Transmusica & Vox Populi et Jazz de la Société Philharmonique de Bruxelles.

Musiques

14 15

charleroi / danses

impressionistic color photography leads the color palette of
this dance company's brochure. Performance descriptions are
isolated in areas of flat color, while booking details stand out in
black type against a white background. A sense of movement is
conveyed throughout the publication by the abstract banded
panels, rendered in different intense colors.

Designer
Nathalie Pollet

Art Directors
Nathalie Pollet, Kate Houben

Illustrator
Nathalie Pollet

Design Company
Designlab

Country of Origin
Belgium

Description of Artwork
Season's program for a
choreographic center

Dimensions
180 x 290 mm
7 x 11²/₅ in

4e Biennale Internationale de Charleroi/Danses

Nomade, elle se déroulera entre Charleroi, Bruxelles, Mons et
Maubeuge, en collaboration avec Ars Musica, le Théâtre du
Manège à Maubeuge, le Centre Culturel Régional de Charleroi, le
Centre Culturel de la Région de Mons, le Théâtre 140.

Au pré-programme : la version longue du spectacle de
Frédéric Flamand/Diller+Scofidio: *EJM¹* "*Man walking at ordinary speed*"; La La La
Human Steps; Toothpick; le nouveau spectacle de la Compagnie Mossoux Bonté (com-
pagnie en résidence au Centre Chorégraphique de la Communauté française pour les
saisons 98-99 et 99-2000)...

L'an 2000 verra la première édition d'une Biennale "nouvelle formule".

4

BIENNALE

Du 19 mars au 1er avril 1999
(Dans le cadre de Via 99)

LE PASS est également valable
pour les spectacles de la Biennale

16 17

 cocktail
 gratuits

Soif et faim de culture...
Une solution: *les **bus** cocktail* de Charleroi/Danses,
la compagnie qui vous transporte avec drinks et zakouskis.

Frédéric Flamand · Charleroi/Danses,Plan K / Ballet de l'Opéra national de Lyon
ven 25 septembre : Charleroi > Bruxelles

Fondation Jean-Pierre Perreault
mar 6 octobre : Charleroi > Bruxelles

Cie Lanônima Imperial · Juan Carlos García
ven 9 octobre : Charleroi > Bruxelles

Cie DCA · Philippe Decouflé
mar 20 octobre : Charleroi > Namur

Robert Lepage
sam 14 novembre : Charleroi > Maubeuge / Bruxelles > Maubeuge

Cie Castafiore
sam 6 février : Bruxelles > Charleroi

Réservation indispensable
07 20 56 45

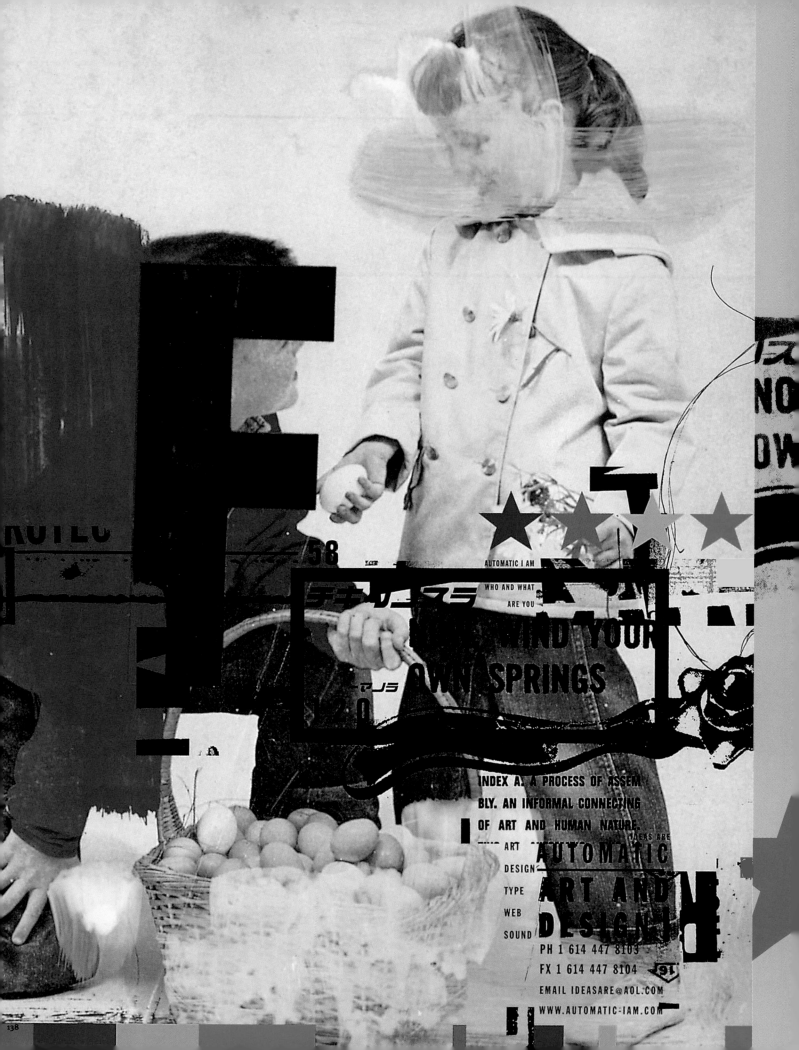

WIND YOUR OWN SPRINGS

AUTOMATIC I AM
WHO AND WHAT
ARE YOU

INDEX A: A PROCESS OF ASSEM
BLY. AN INFORMAL CONNECTING
OF ART AND HUMAN NATURE.

ART AUTOMATIC
DESIGN
TYPE ART AND
WEB
SOUND DESIGN

PH 1 614 447 8103
FX 1 614 447 8104
EMAIL IDEASARE@AOL.COM
WWW.AUTOMATIC-IAM.COM

Designer
Charles Wilkin

Art Director
Charles Wilkin

Illustrator
Charles Wilkin

Design Company
Automatic Art and Design

Country of Origin
USA

Description of Artwork
Creative book advertisement
for Automatic Art and Design

Dimensions
Various

automatic art and design

this self-promotional advertisement for design
group automatic draws together an eclectic range
of found imagery as well as pieces of corporate
stationery, suggesting the uncompromisingly
daring aesthetic of the company. Variety is added
not only through the images employed, but
through their colors and media – paint, litho
print, and heavy blocked line.

GLOSSARY

OF USEFUL TERMS

Bleed
The printed area outside the **trim marks** on a page. Bleed printing achieves a clean edge where color is run to the borders of page.

Blueline, blue, or ozalid
A **proof** made from **film** that is subsequently used to make the printing **plates**; usually the last proof made before printing.

CMYK
Alternative term for the **four-color process**. The letters stand for cyan, magenta, yellow, and key (black).

Coated paper or art paper
Paper that has a fine china clay slurry applied to its surface during manufacture, giving it a very smooth surface. Less ink is absorbed into the paper during printing, making for brighter colors and greater detail.

Coverage
The area of paper actually covered with ink during printing. For example, a page completely covered with words may only have a coverage of 15 per cent.

Cutout
Image without a background.

Die-cutting
A **letterpress** process that uses a die made of sharpened steel that can cut or perforate paper in almost any shape.

Duotone
A **halftone** that prints in two colors to create greater visual interest or to hold detail.

Film
A photographic emulsion that records the detail of all text and **halftones** to be printed. It is used to make printing **plates** through a further photochemical process.

Fluorescent ink
Printing ink that uses special pigments which reflect greater amounts of light than usual, making the ink much brighter.

Foil-stamping
A **letterpress** process that uses heat to transfer thin metal or plastic onto paper to make an image or type.

Four-color process
The printing process by which full-color photographs and artworks may be reproduced. Four **halftones**, one for each of the colors cyan, magenta, yellow, and black, are printed one on top of the other, recreating the range of color of the original.

Halftone
Image broken down into dots so fine that they cannot easily be seen with the naked eye, thus giving the impression of a continuous-tone image, such as a photograph. Halftones must be made to print photographs and artworks because printing presses can only print solid color. In order to print tints and photographs, the solid colors are broken down into dots.

Laminate
A layer of plastic or foil bonded to the whole surface of a board or sheet of paper. Matt or gloss laminates are used to add texture to a printed product or to protect it from handling damage.

Letterpress
Any printing process where ink is applied to a raised image and directly pressed on to paper. Years ago this was the most common form of printing but now it is used mainly for **die-cutting** and **foil-stamping**.

Litho
Abbreviation of lithography, the method of printing in which ink is transferred from a chemically treated flat **plate** to paper.

Match print
A color **proof** made from the printing film of a **four-color process** piece, but not usually on the intended paper. This is the most accurate color proof available apart from a **wet proof**.

Metallic ink
Printing ink which includes pigments that resemble metal. These inks are sometimes made by adding powdered brass or aluminum to an ink, giving the impression of gold or silver respectively.

Overprinting
The printing of one color on top of another.

Pantone Matching System (PMS)
A widespread standard for the selection of color to be used in print. Thousands of color samples, identified by unique codes, are printed in swatch books; these codes are used by printers to mix inks of an exactly corresponding color.

Plate
Thin metal sheet that carries the detail of all text and **halftones** to be printed. The plate is fixed into place on a litho printing press: ink applied to the plate sticks to the image areas and is repelled from non-image areas.

Proof
An impression taken from a printing surface, such as a **film** or **plate**, or (increasingly) generated directly from digital data. It closely represents the work to be printed, allowing inspection and amendment of any errors before the printing commences.

Reverse out or knock out
In printing, the technique of creating text or image by taking away the color from beneath an area to let the paper beneath show through.

Signature or section
Books are often produced by printing a number of pages (typically 8, 16, or 32) onto a single large sheet. Each of these sheets is then folded and cut to form a section, or signature, of the book.

Silk screen
A method of printing in which ink is forced through a mesh made from fine material (originally silk) onto the surface to be printed.

Spot color or special color
An ink mixed specially to a color picked out of a chart, such as the **Pantone Matching System**.

Tint
A percentage of a printed solid color.

Trim marks
Cutting guides marked outside the intended print area that set the final size to which the paper will be cut.

Tritone
A **halftone** that prints in three colors to create greater visual interest or to hold more subtle detail than a single color halftone or **duotone**.

Typography
Defining the form of typeface and style and format of text.

Uncoated paper
Paper that is not treated with clay slurry during manufacture. See **coated paper**.

Varnish
An oil, water, or synthetic varnish applied to printed paper to enhance its appearance. Can be applied uniformly over the surface or to specific areas (spot varnish).

Wet proof
Proof produced from the final printing **plates** on the intended paper. It shows the exact effect that will be achieved during printing.

INDEX

OF DESIGNERS AND DESIGN COMPANIES

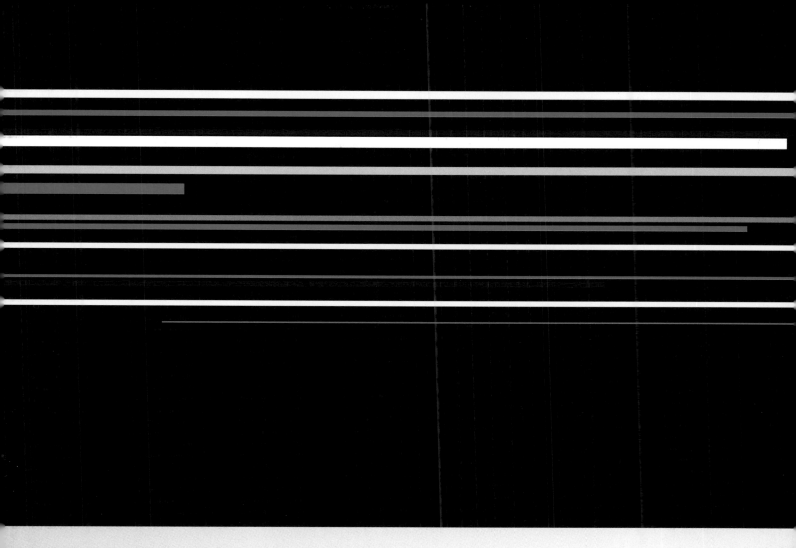

ABCDEFGHIJKL
MNOPQRSTUV
WXYZ

ESPAI GRÀFIC
Cervantes, 6
08700 Igualada
Barcelona
Spain

Tel 93 805 32 00
Fax 93 803 10 13

espai grafic address label

recyclable · ricicla